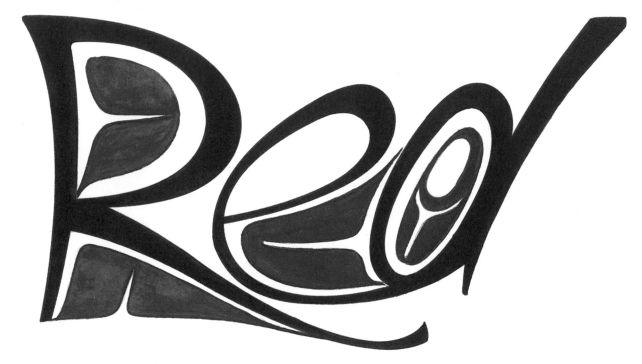

A HAIDA MANGA

MICHAEL NICOLL YAHGULANAAS

DOUGLAS & MCINTYRE
D&M PUBLISHERS INC.
VANCOUVER/TORONTO/BERKELEY

COPYRIGHT © 2009 BY MICHAEL NICOLL YAHGULANAAS
FIRST U.S. EDITION 2010

09 10 11 12 13 5 4 3 2 1

DOUGLAS & MCINTYRE
AN IMPRINT OF D&M PUBLISHERS INC.
2323 QUEBEC STREET, SUITE 201
VANCOUVER BC CANADA V5T 4S7
WWW.DOUGLAS-MCINTYRE.COM

LIBRARY AND ARCHIVES CANADA CATALOGUING IN PUBLICATION
YAHGULANAAS, MICHAEL NICOLL
 RED : A HAIDA MANGA / MICHAEL NICOLL YAHGULANAAS.
 ISBN 978-1-55365-353-0
 1. HAIDA INDIANS—COMIC BOOKS, STRIPS, ETC. I. TITLE.
 PN6733.Y34 2009 741.5'971 C2009-900904-8

EDITING BY CHRIS LABONTÉ
JACKET DESIGN BY PETER COCKING AND MICHAEL NICOLL YAHGULANAAS
JACKET ILLUSTRATION BY MICHAEL NICOLL YAHGULANAAS
INTERIOR LETTERING BY ED BRISSON
PRINTED AND BOUND IN CANADA BY FRIESENS
PRINTED ON PAPER THAT DOES NOT CONTAIN MATERIALS FROM OLD-GROWTH FORESTS
DISTRIBUTED IN THE U.S. BY PUBLISHERS GROUP WEST

WE GRATEFULLY ACKNOWLEDGE THE FINANCIAL SUPPORT OF THE CANADA COUNCIL FOR THE
ARTS, THE BRITISH COLUMBIA ARTS COUNCIL, THE PROVINCE OF BRITISH COLUMBIA THROUGH
THE BOOK PUBLISHING TAX CREDIT AND THE GOVERNMENT OF CANADA THROUGH THE BOOK
PUBLISHING INDUSTRY DEVELOPMENT PROGRAM (BPIDP) FOR OUR PUBLISHING ACTIVITIES.

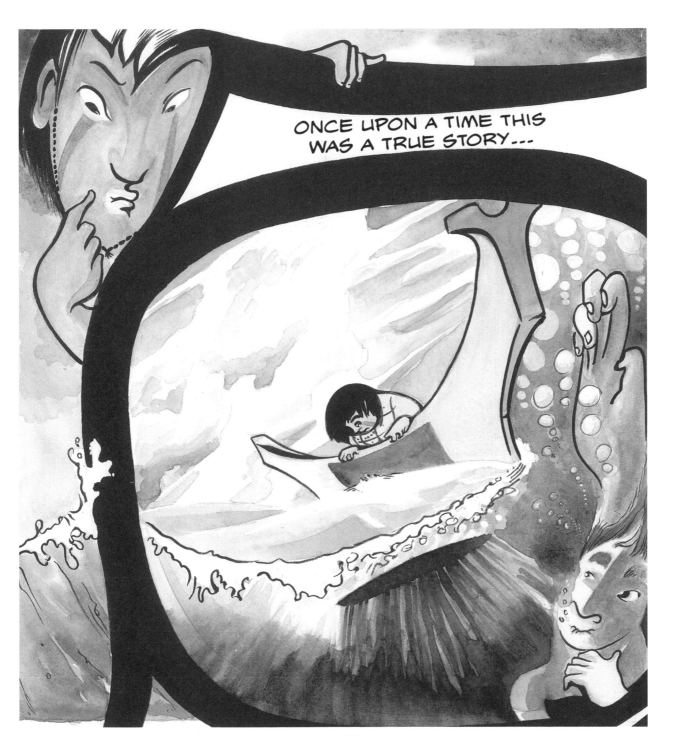

ONCE UPON A TIME THIS
WAS A TRUE STORY...

1

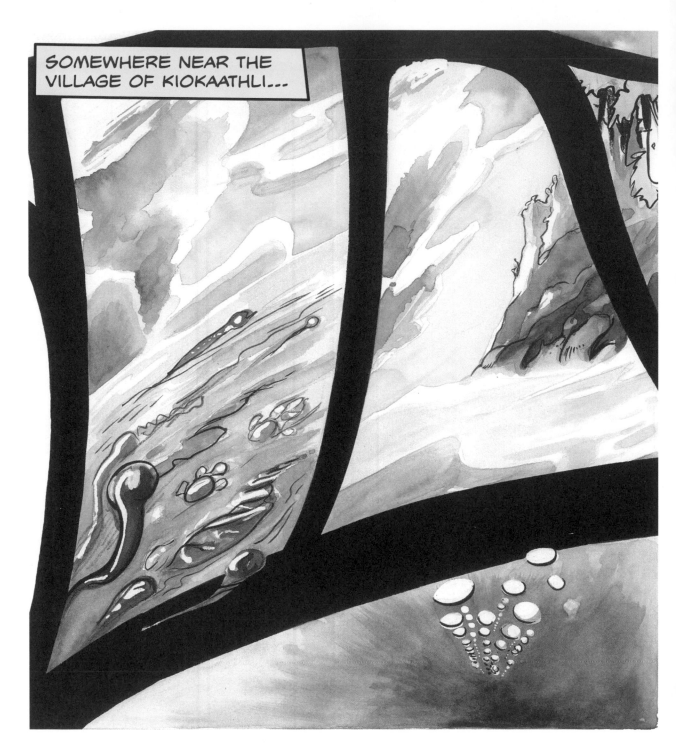

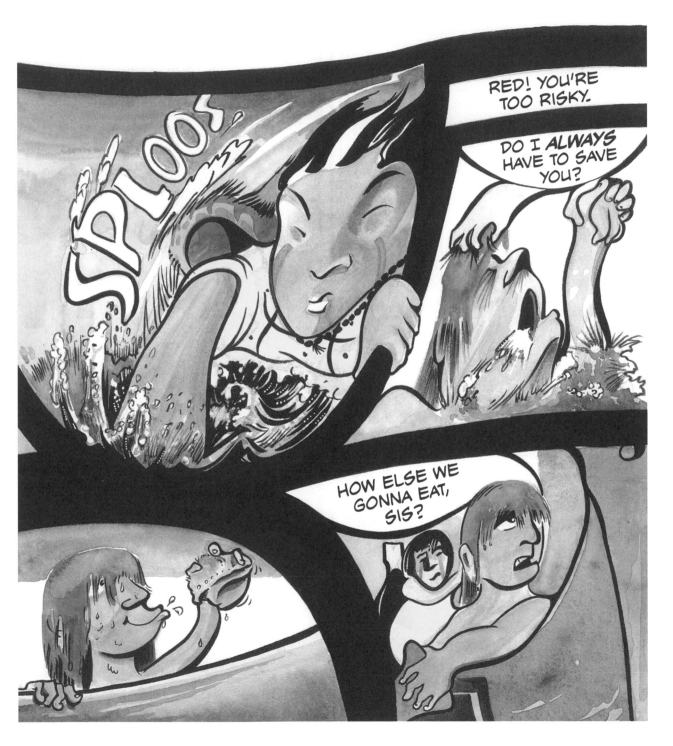

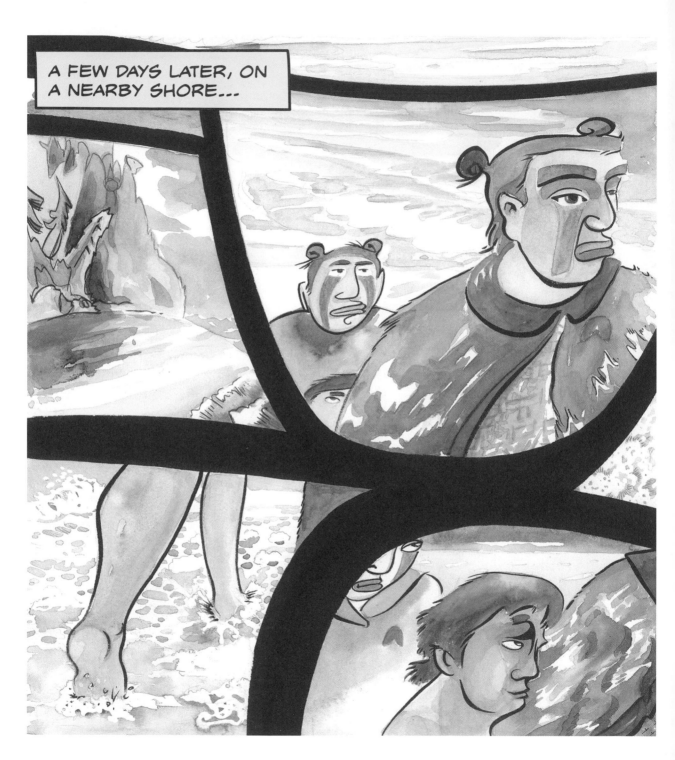

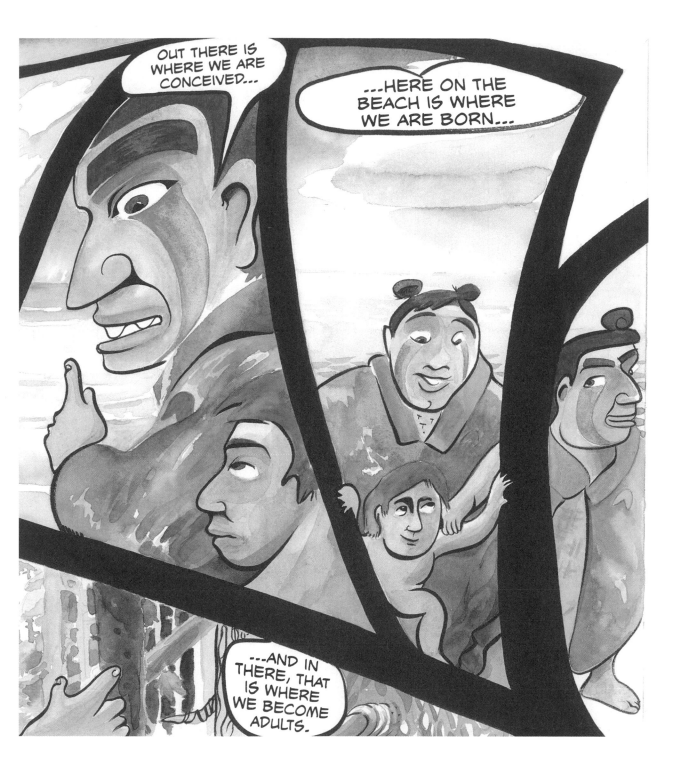

5

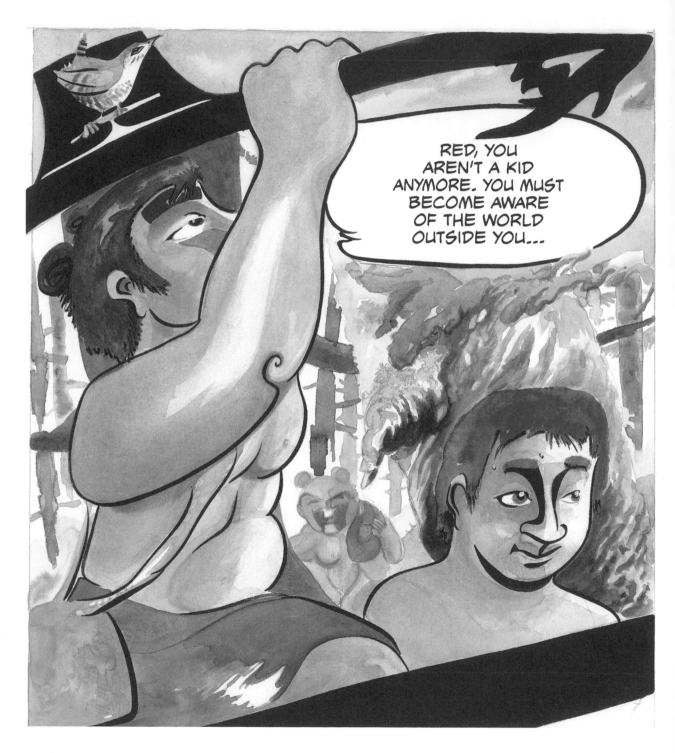

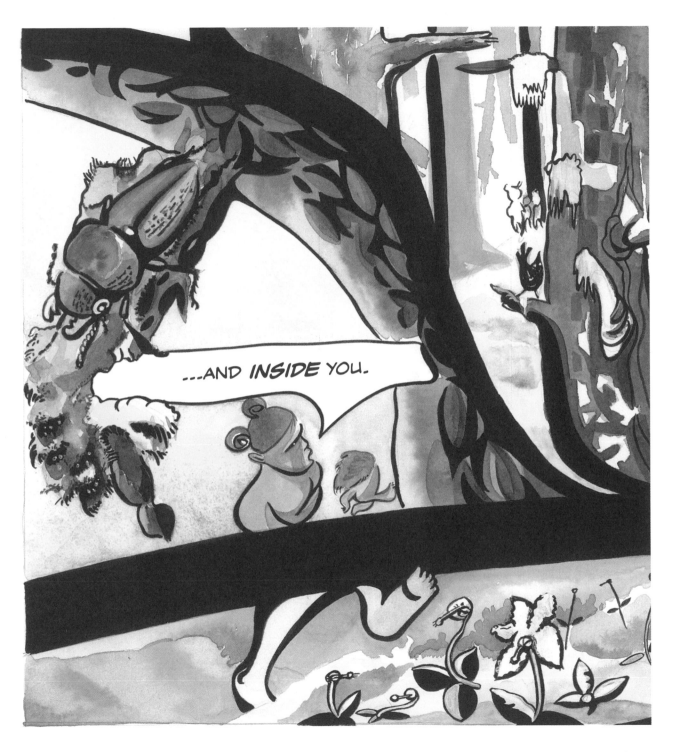

7

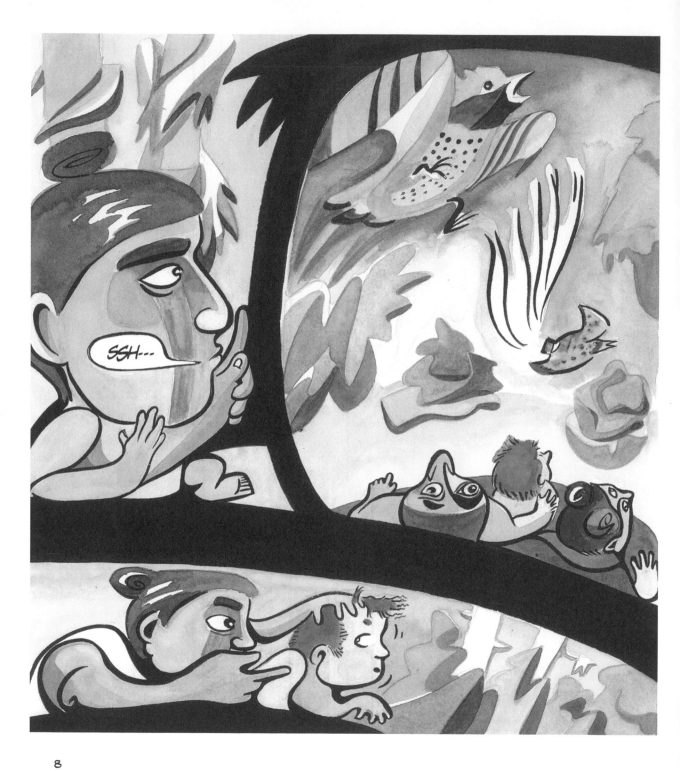

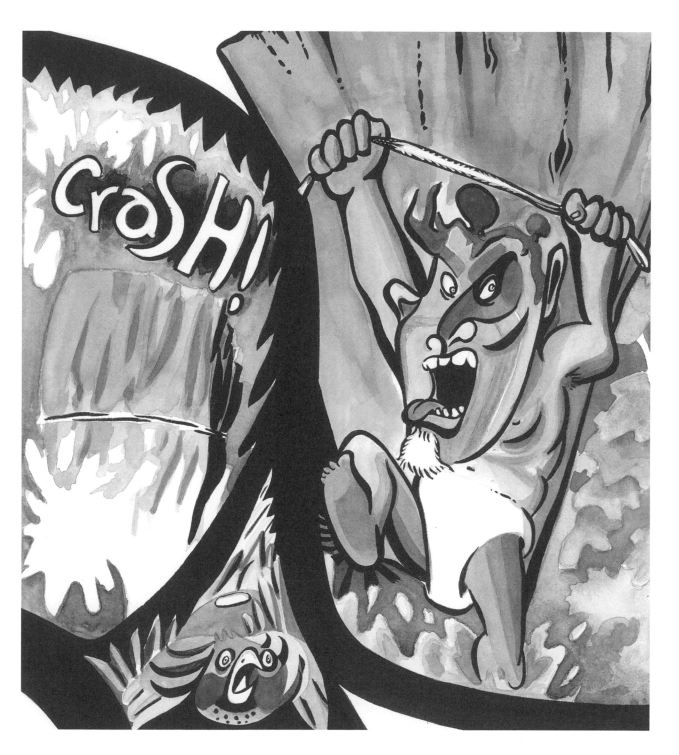

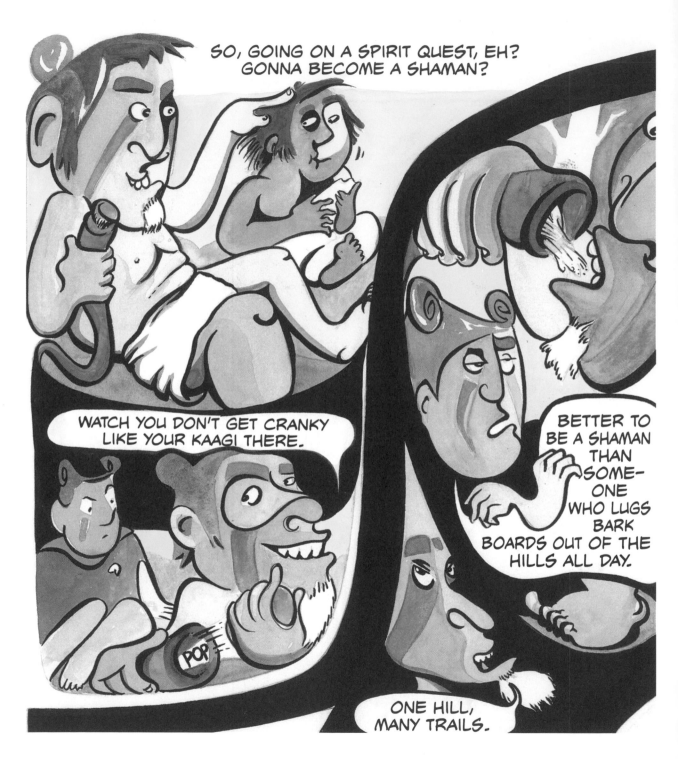

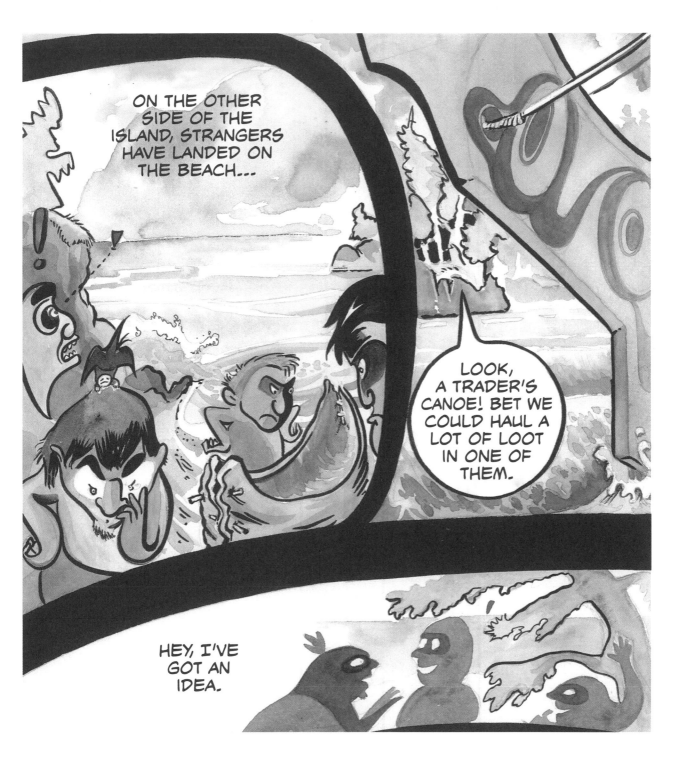

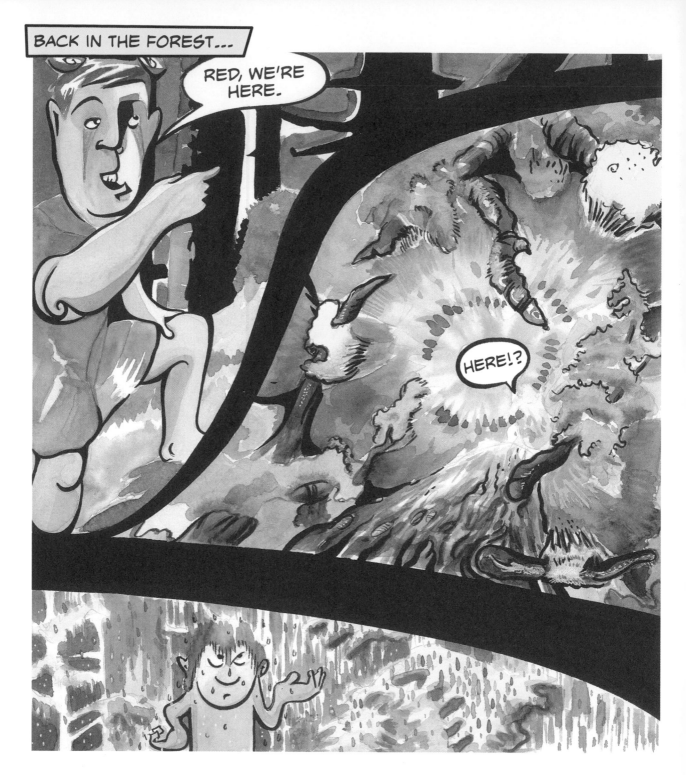

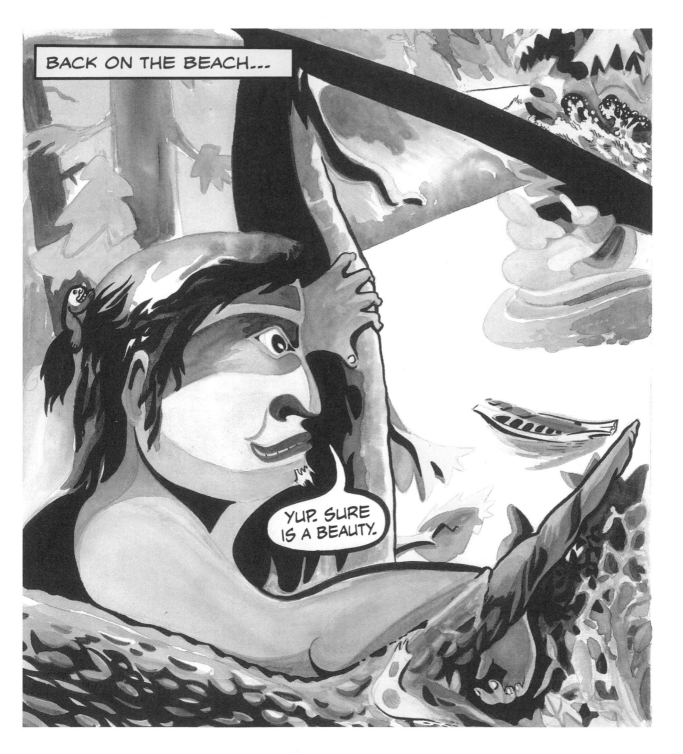

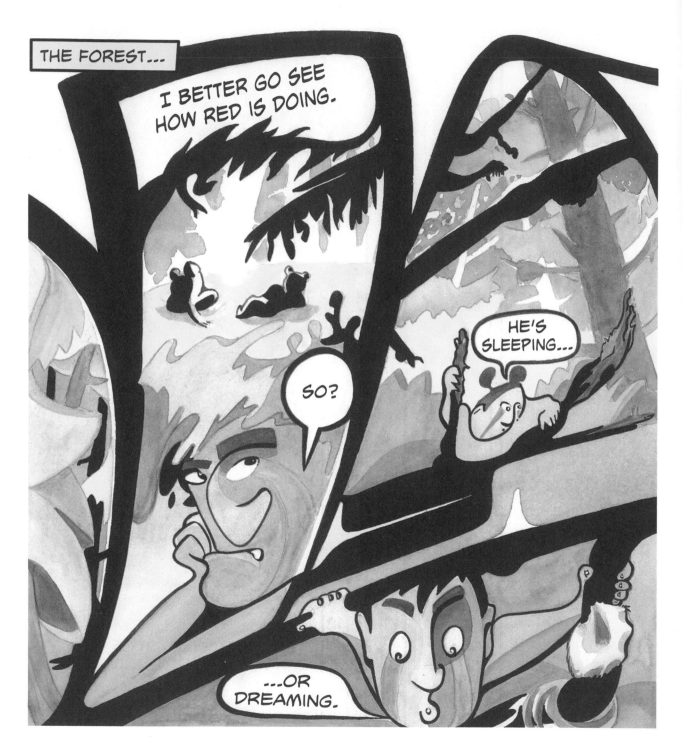

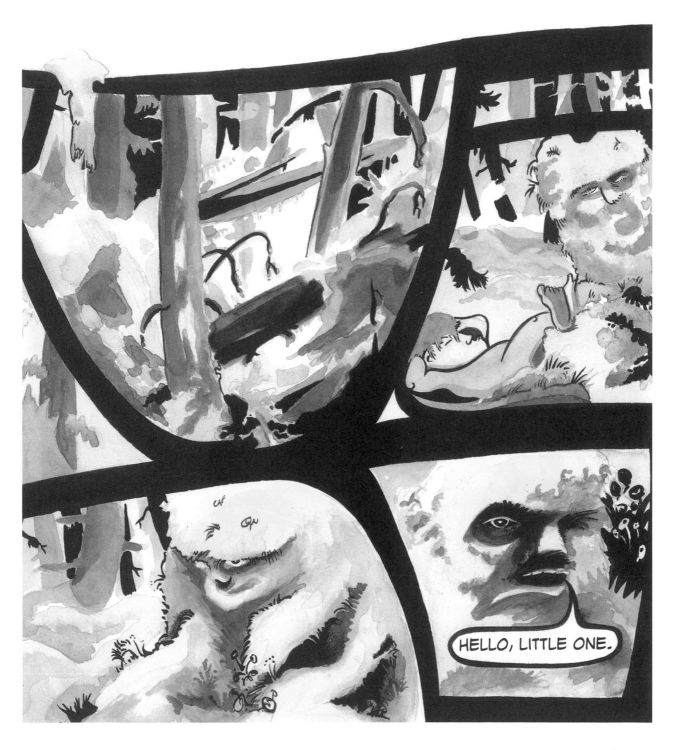

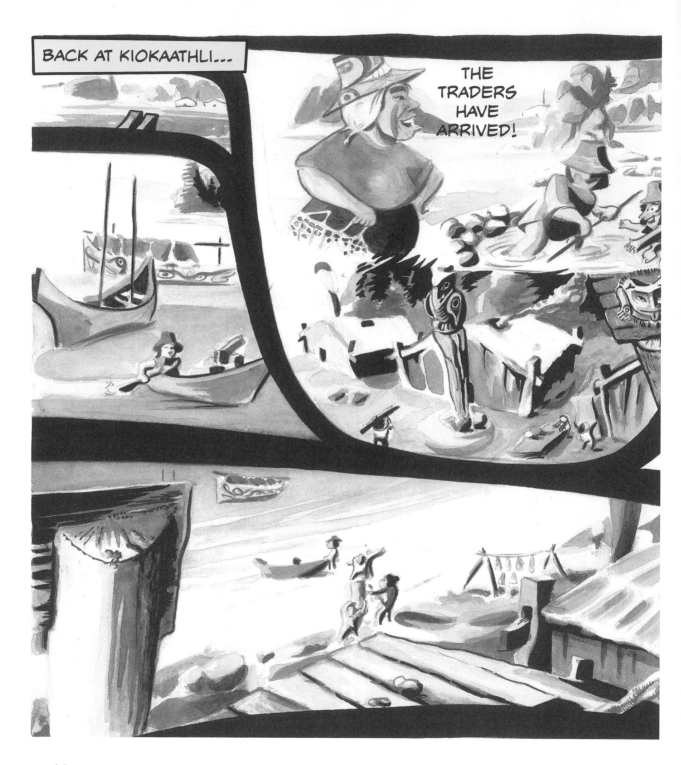

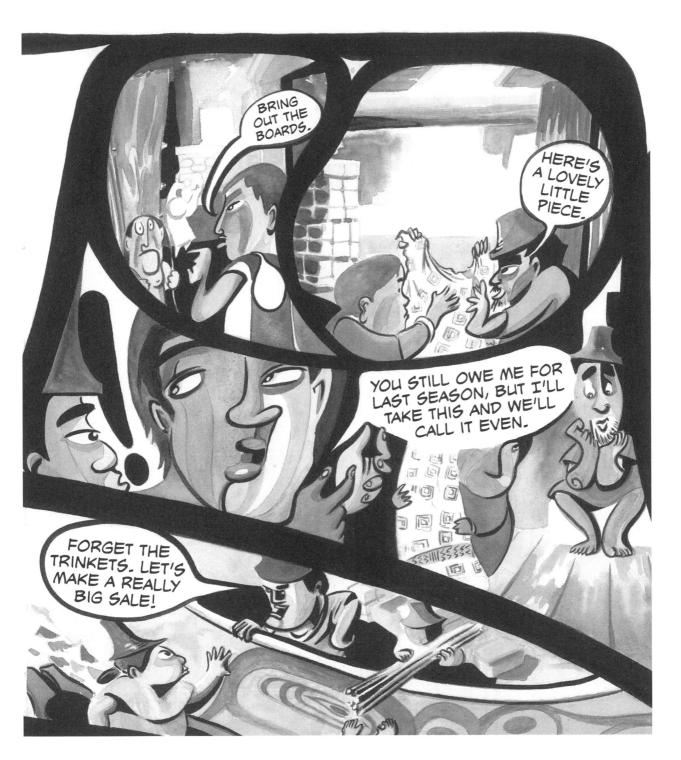

17

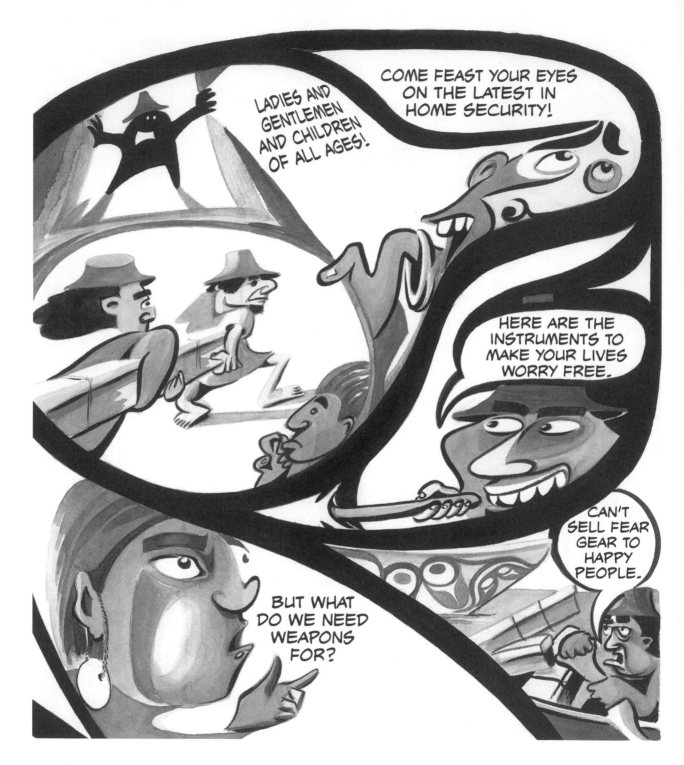

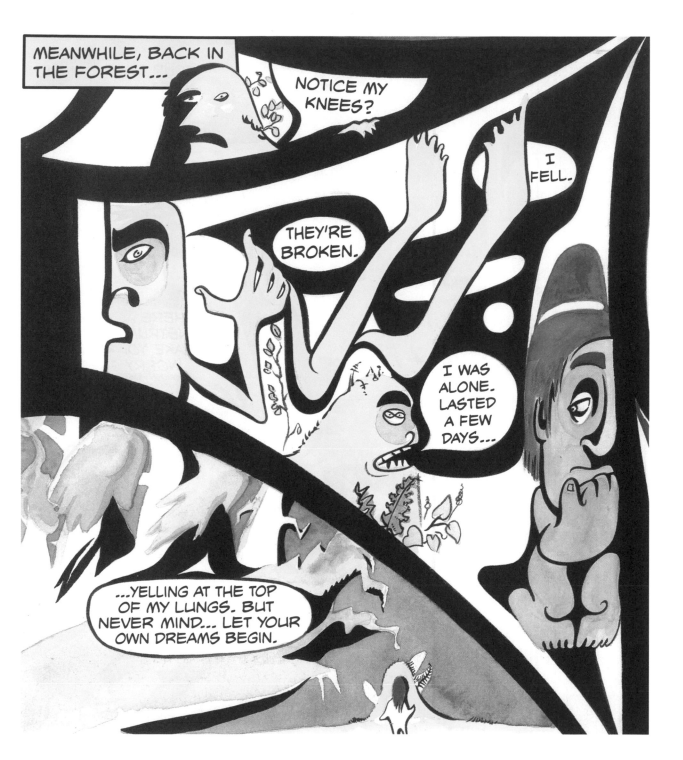

19

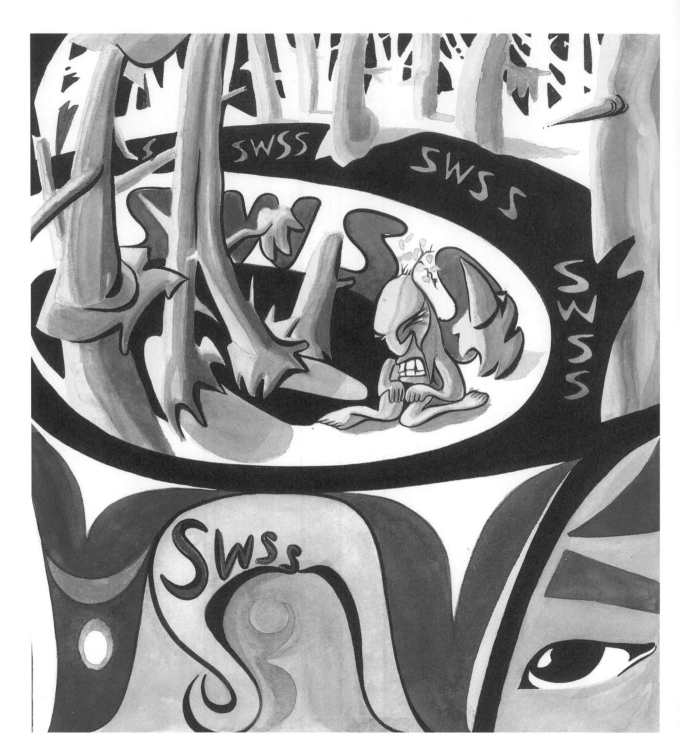

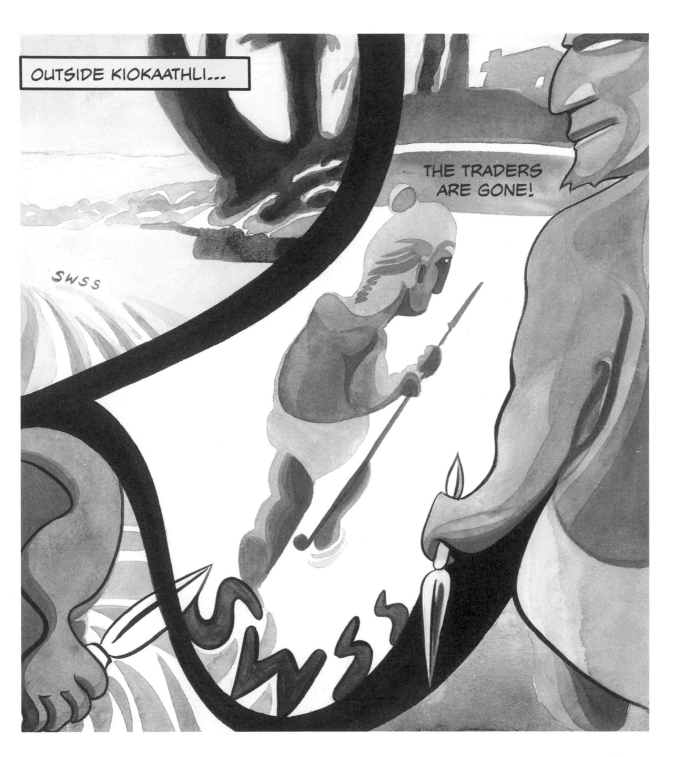

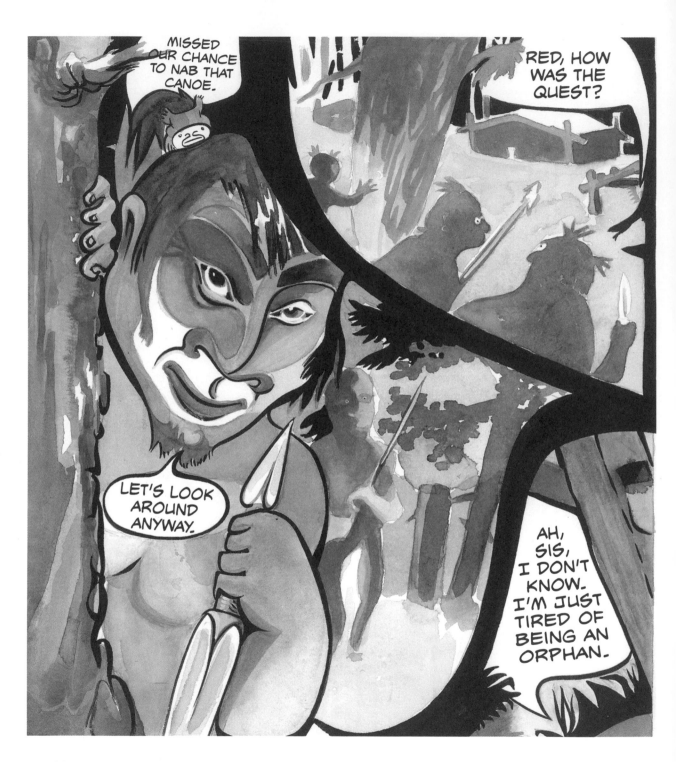

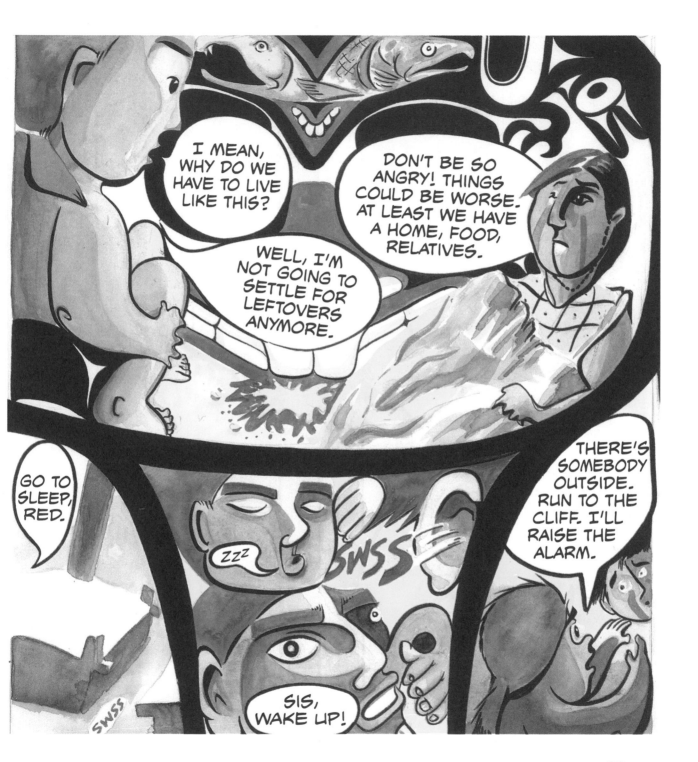

23

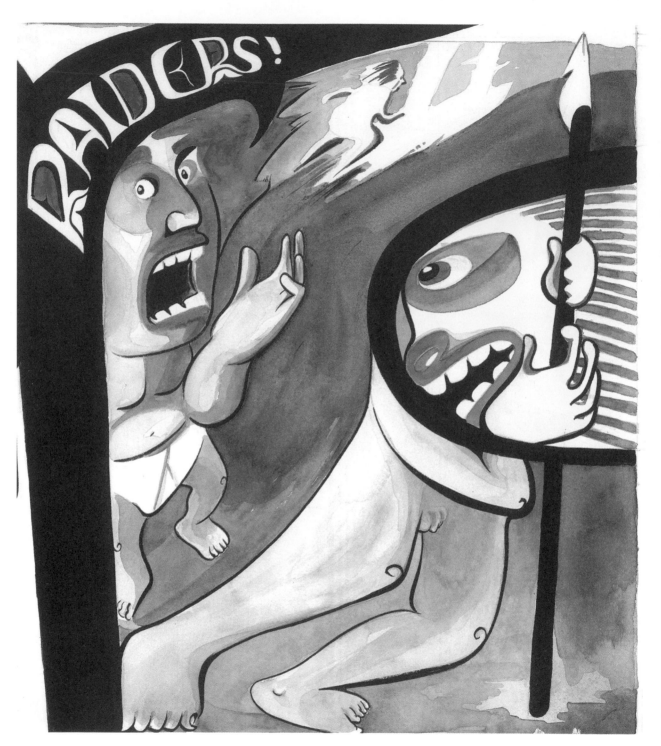

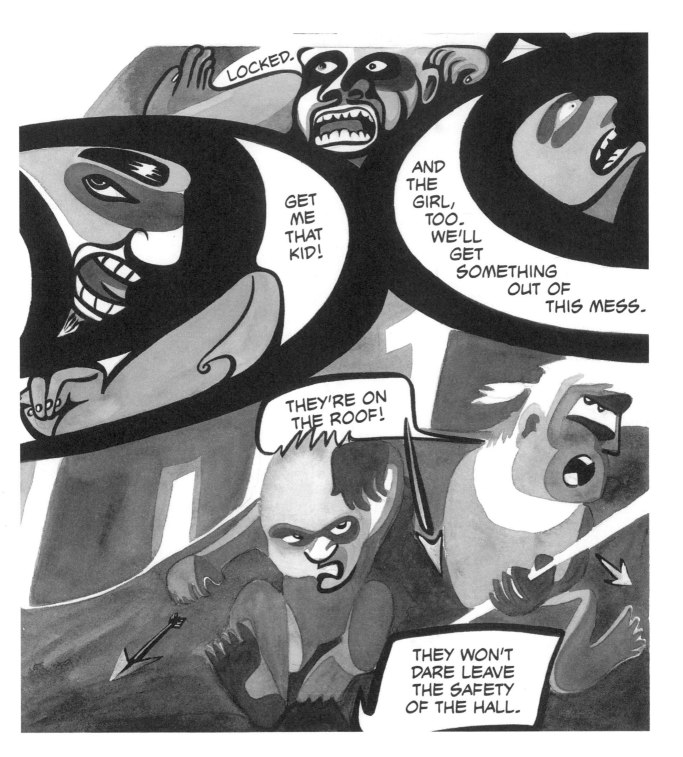

25

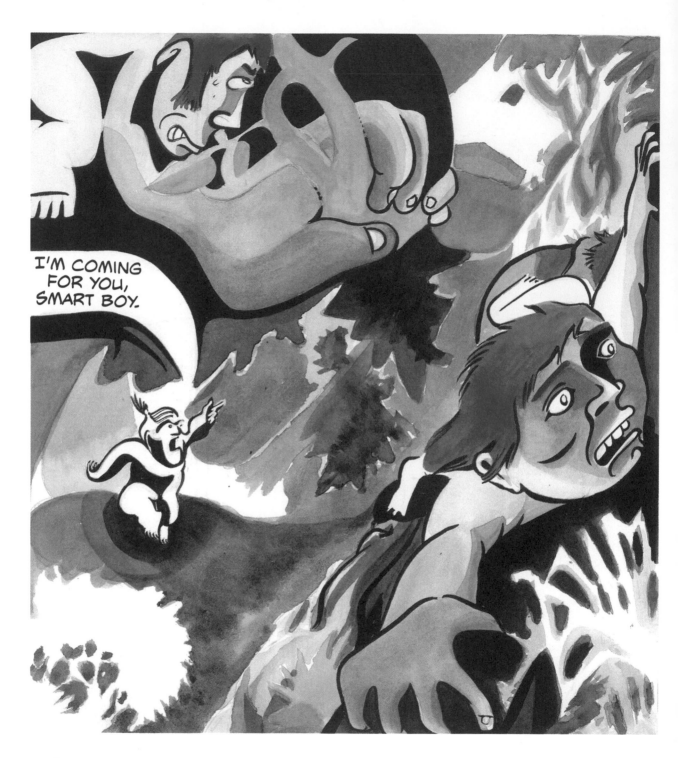

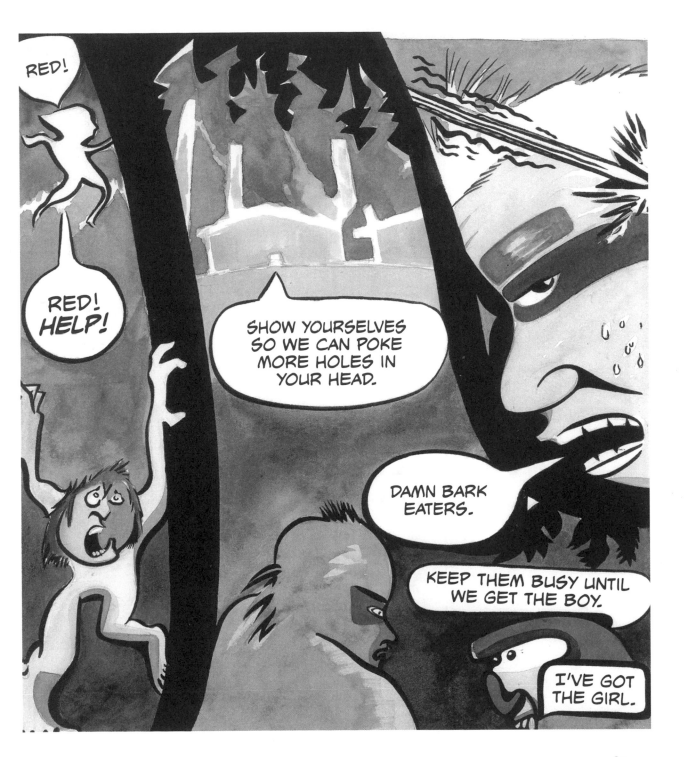

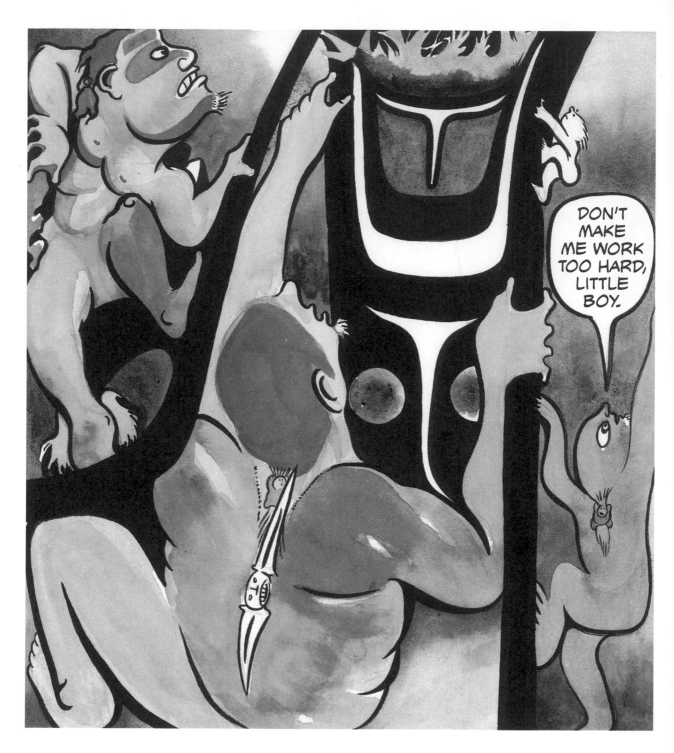

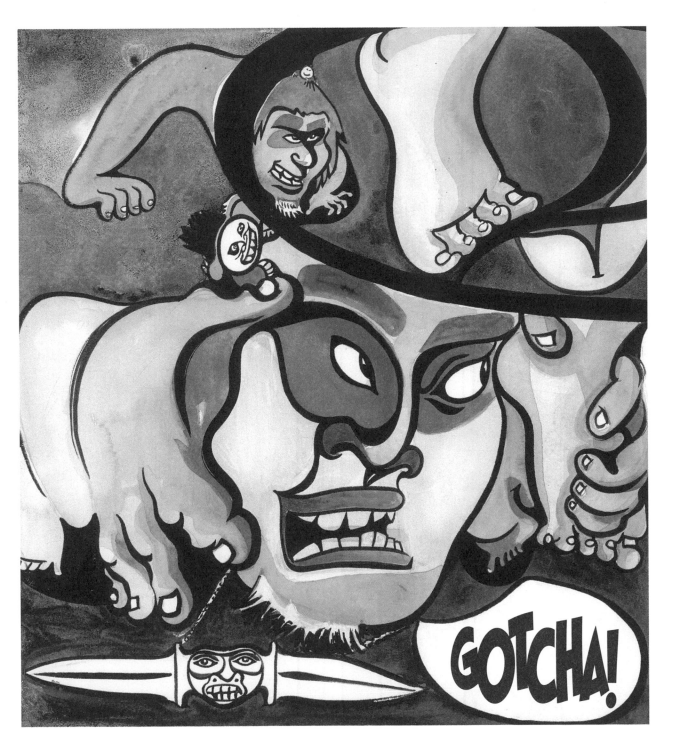

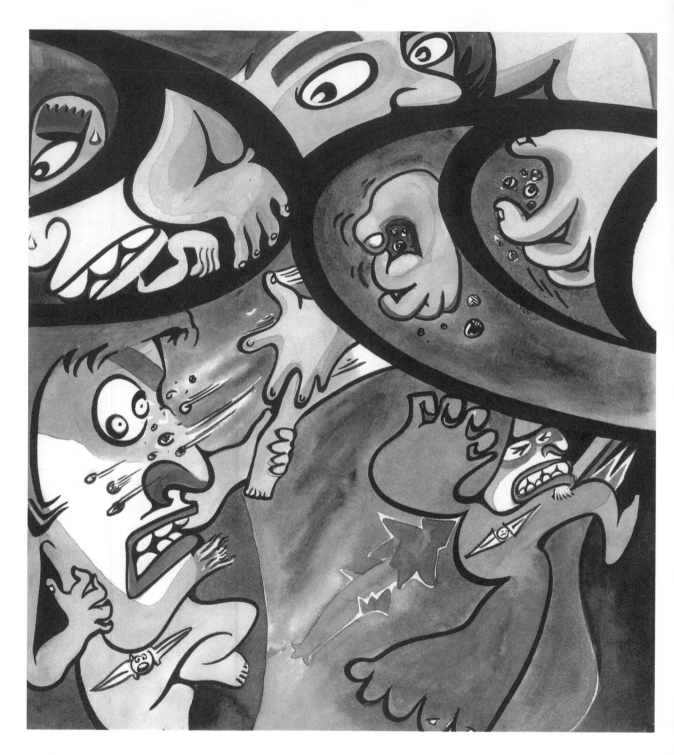

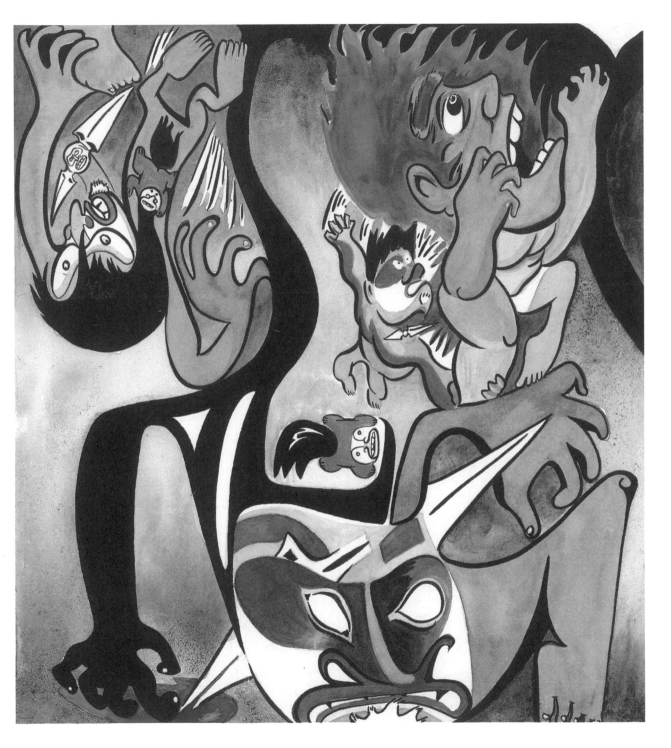

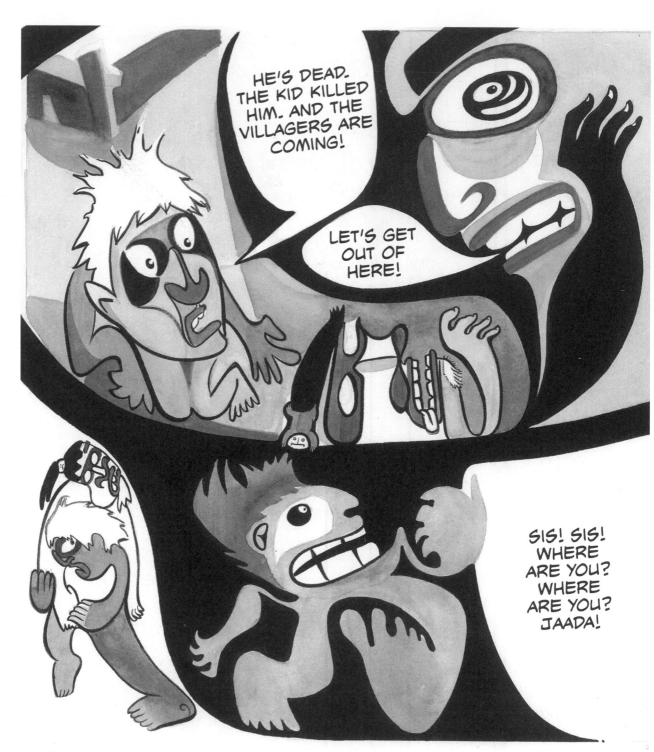

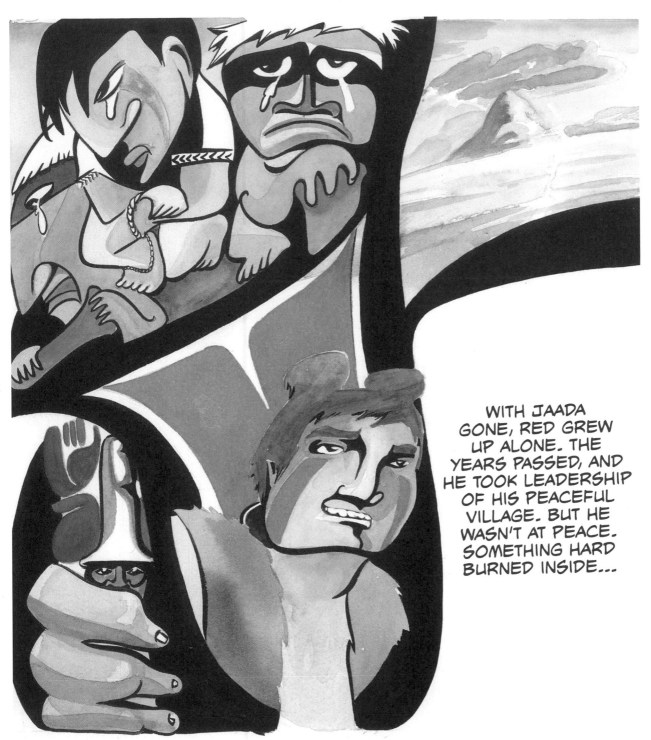

WITH JAADA GONE, RED GREW UP ALONE. THE YEARS PASSED, AND HE TOOK LEADERSHIP OF HIS PEACEFUL VILLAGE. BUT HE WASN'T AT PEACE. SOMETHING HARD BURNED INSIDE...

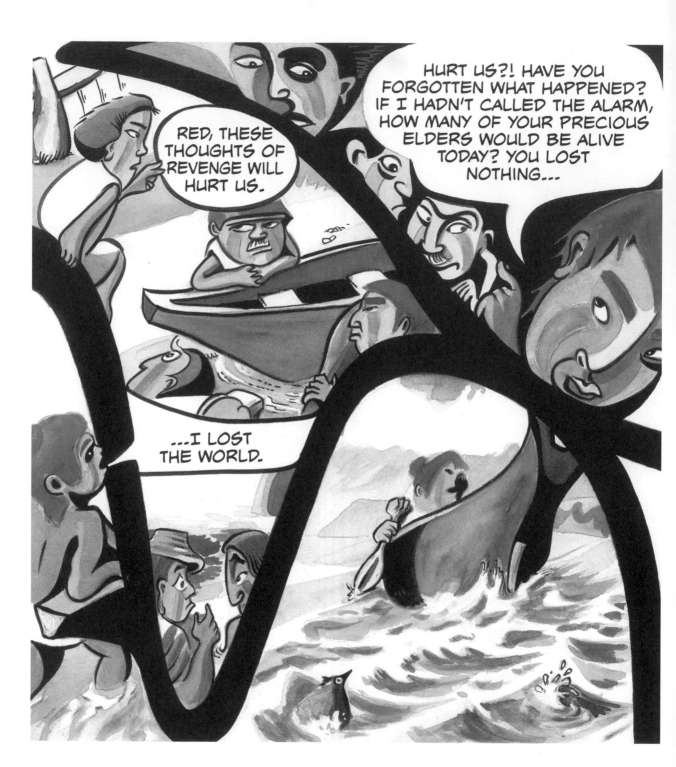

34

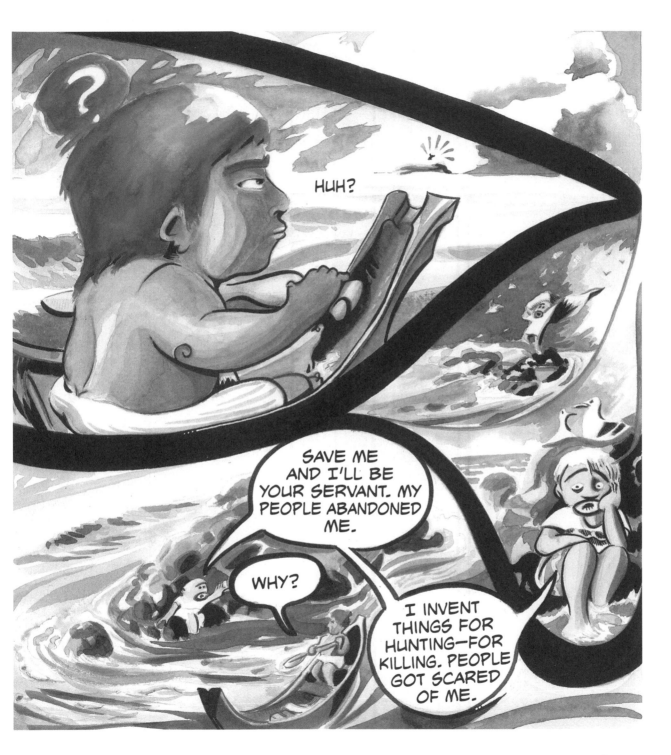

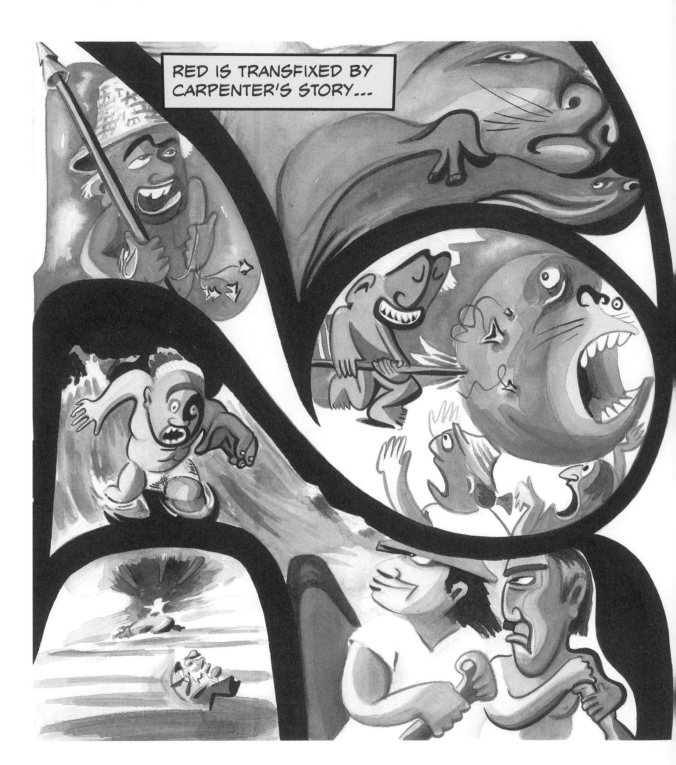

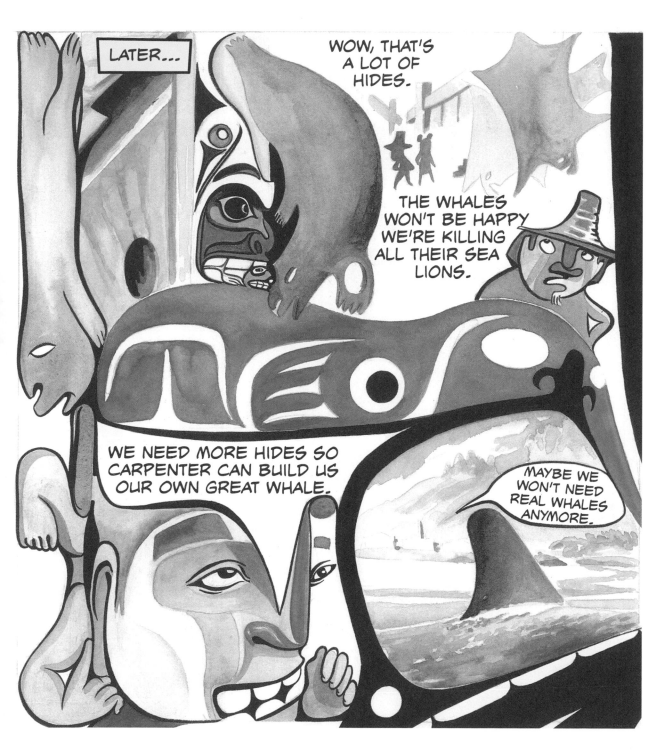

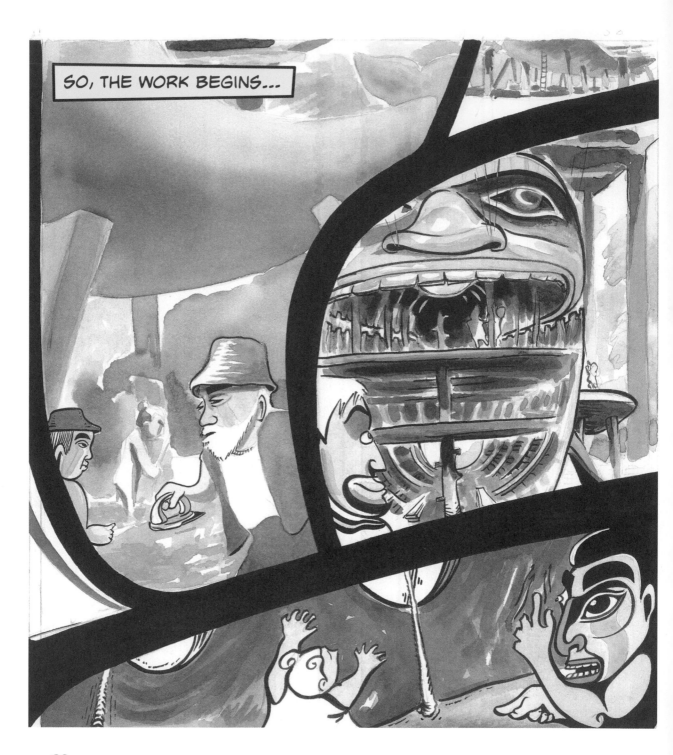

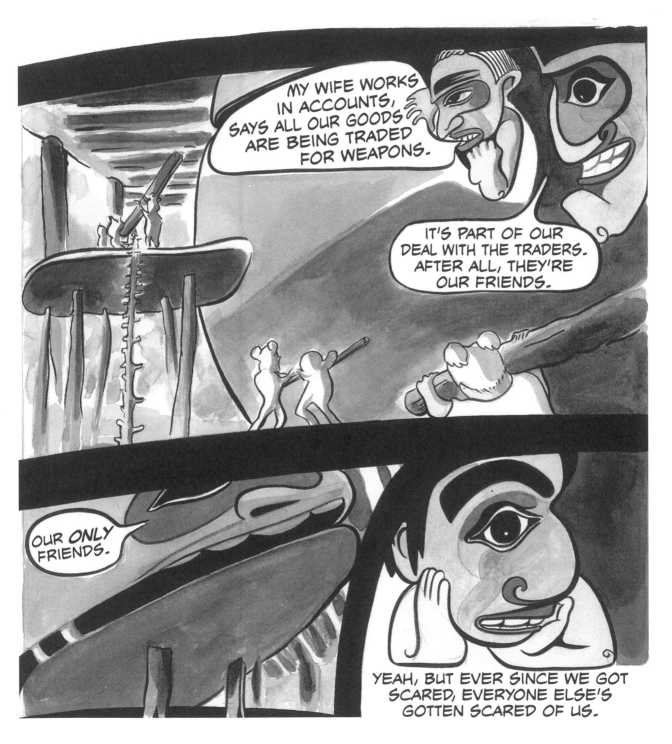

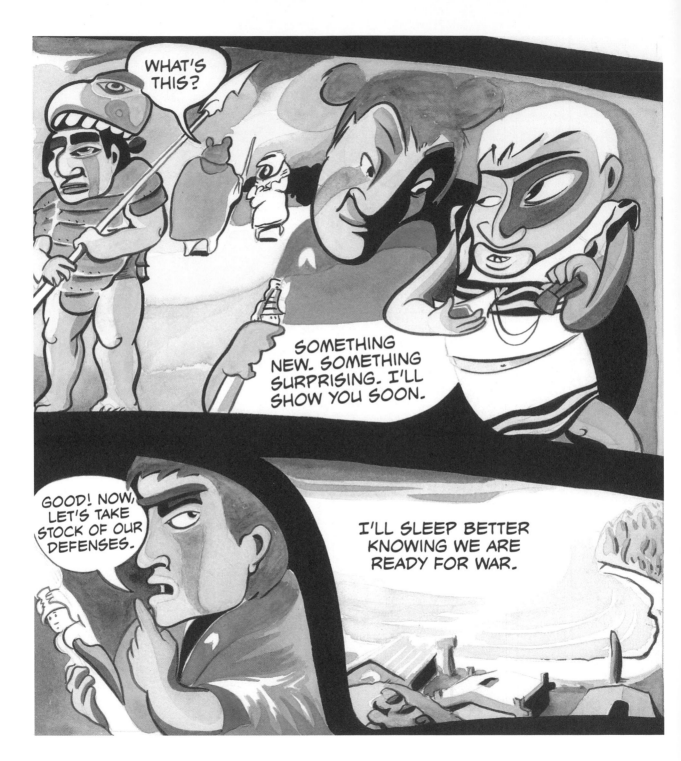

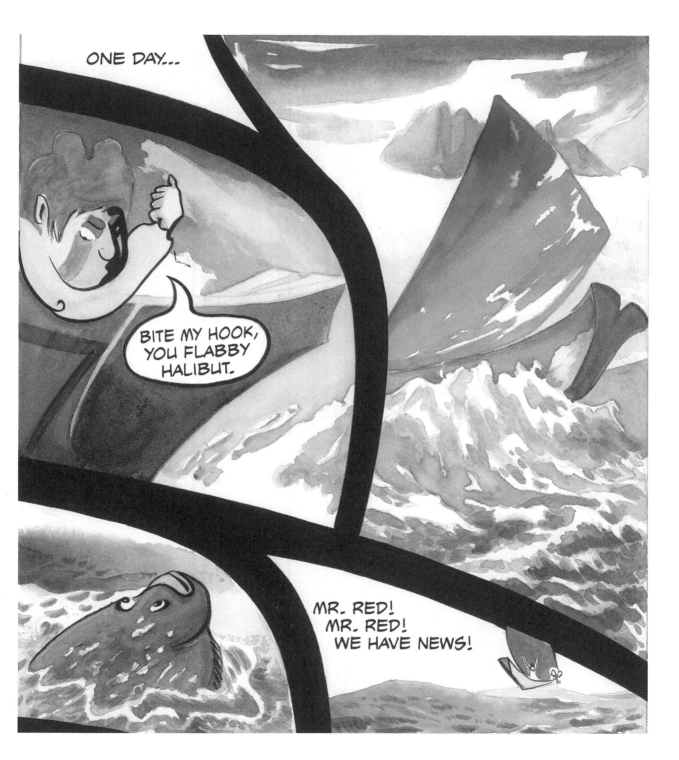

41

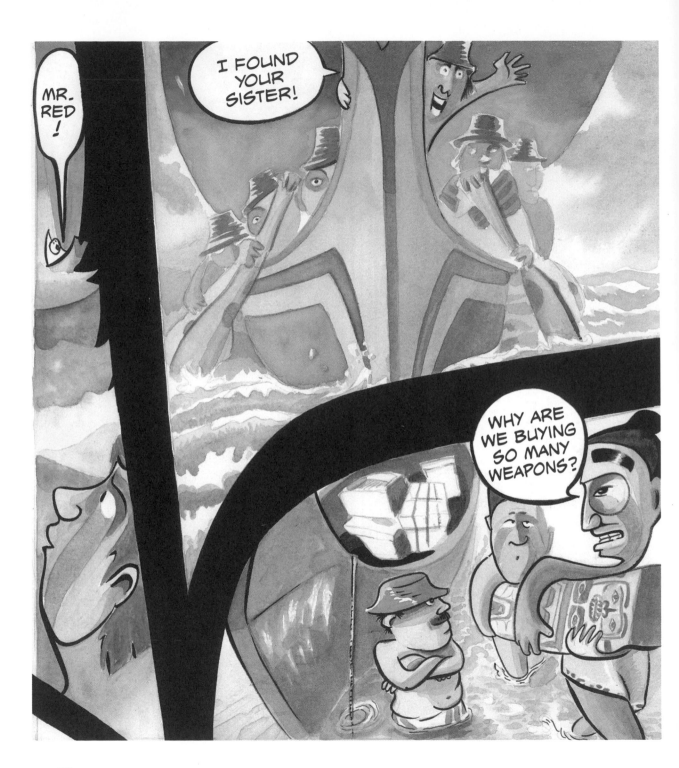

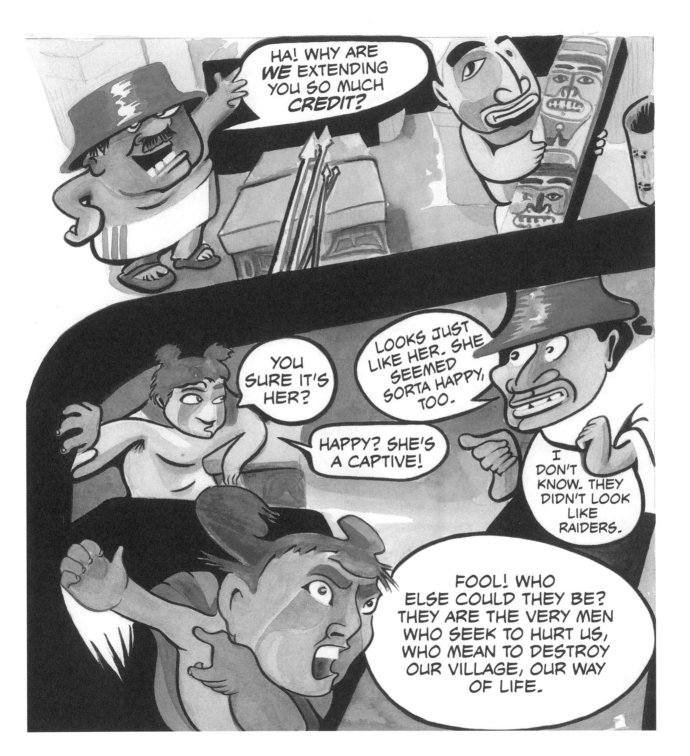

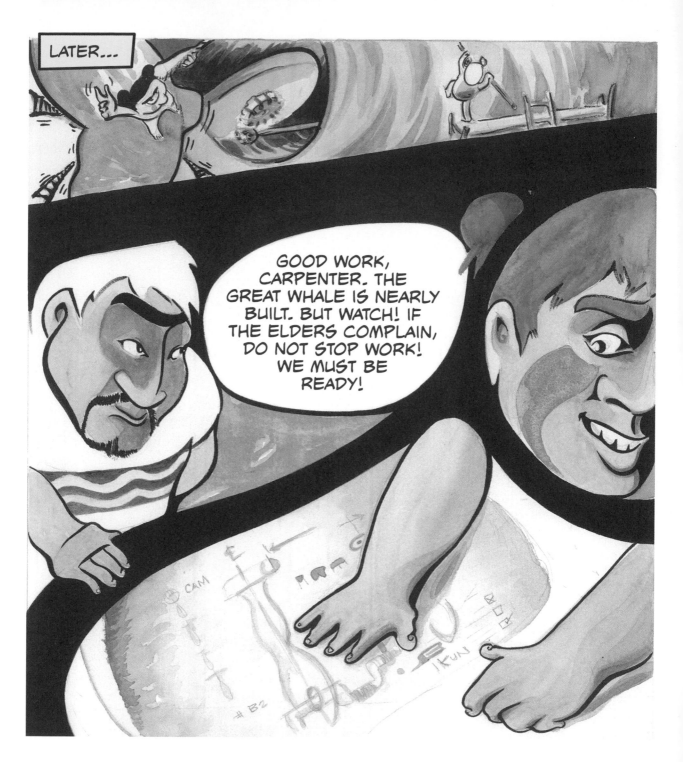

44

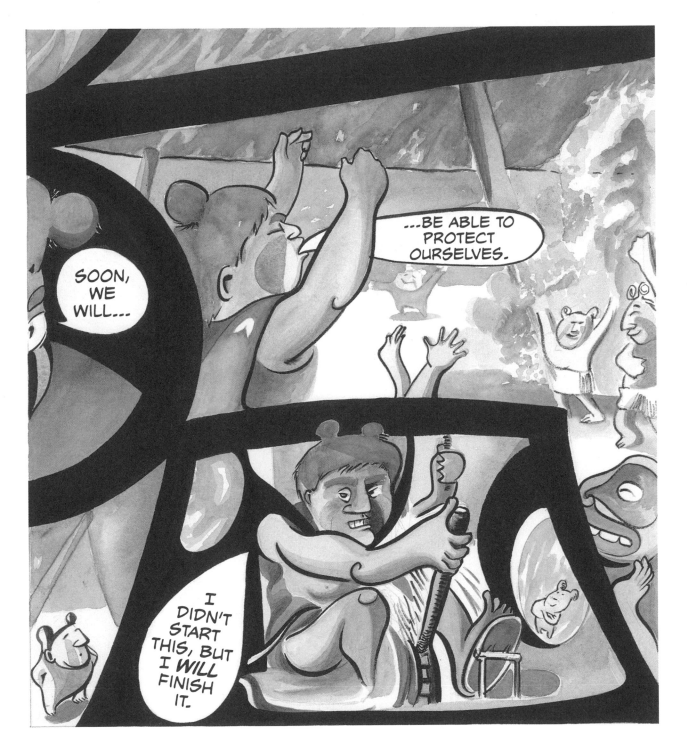

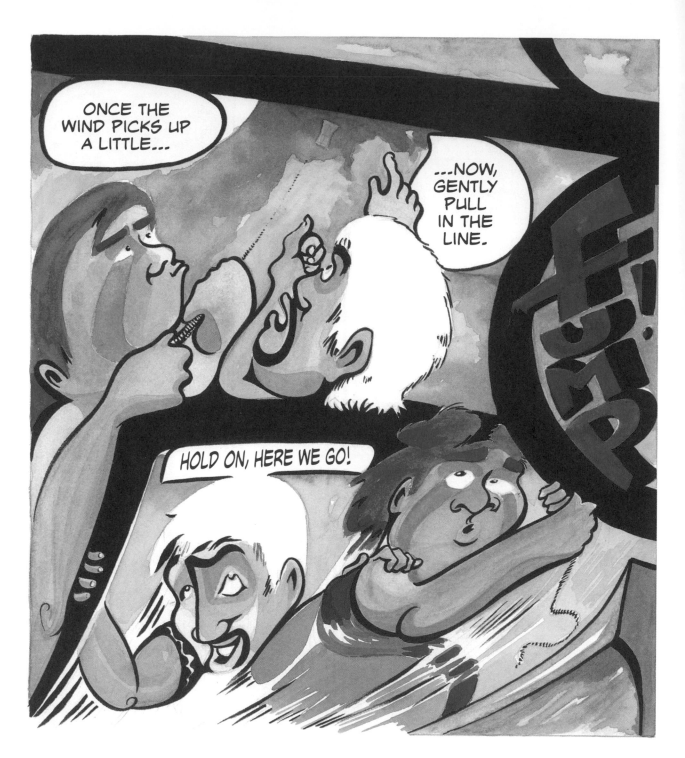

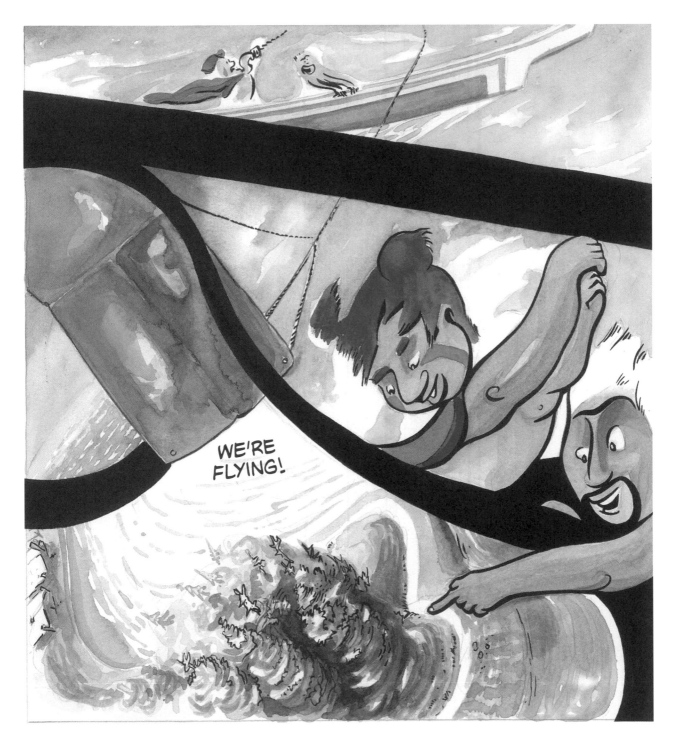

47

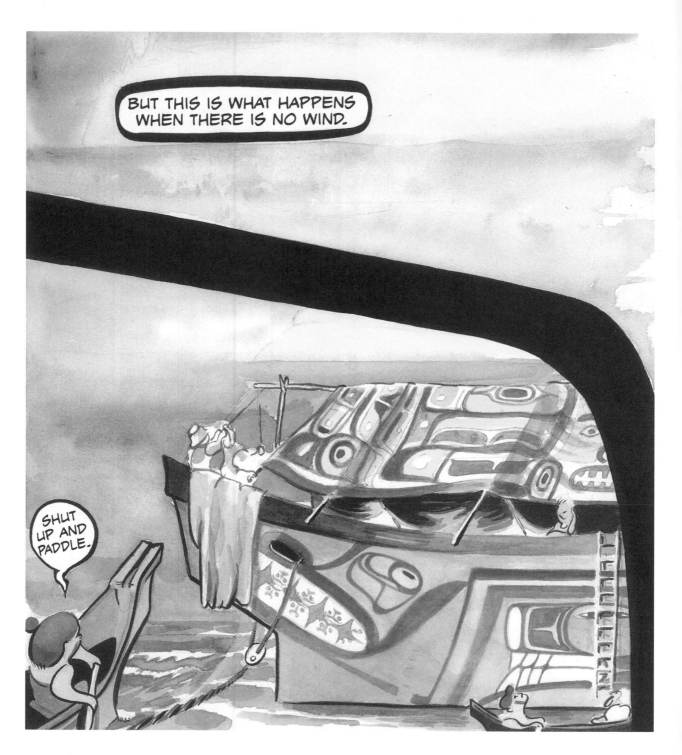

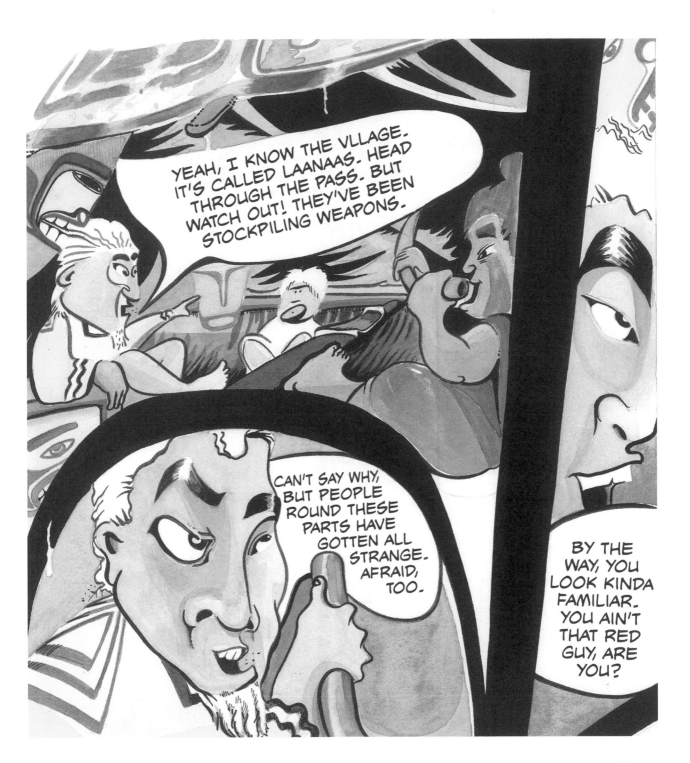

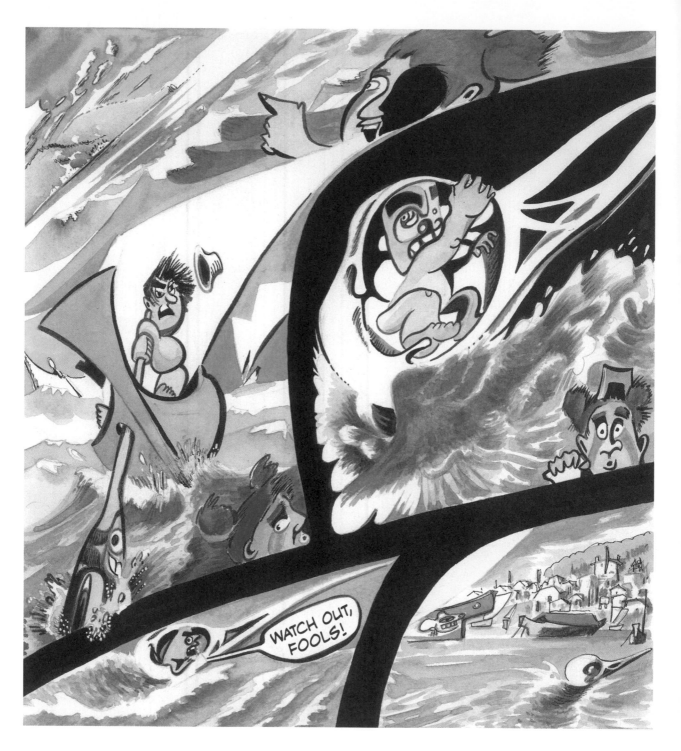

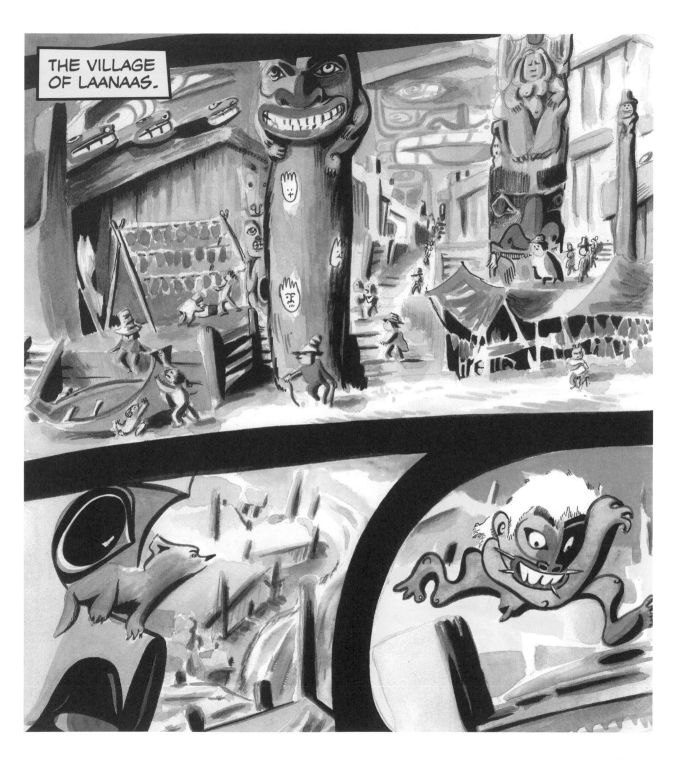

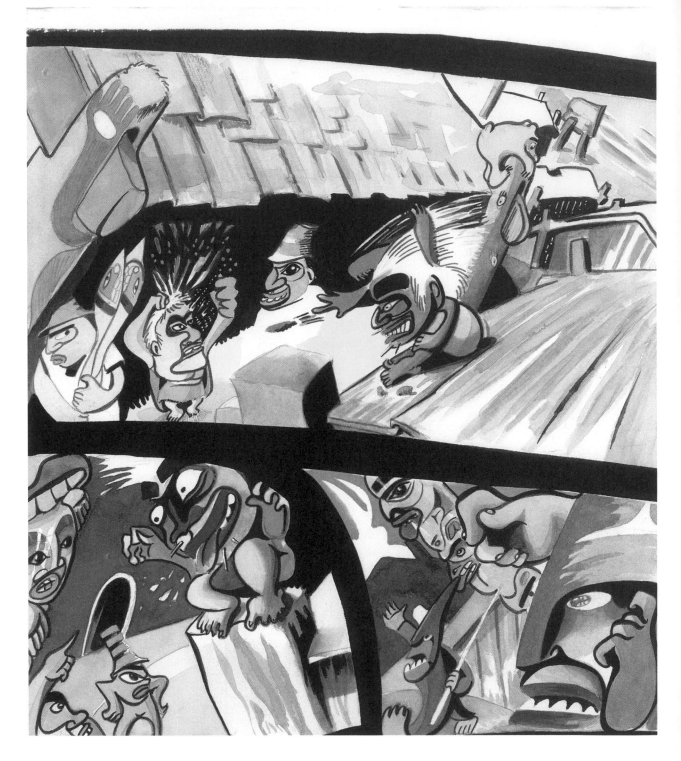

52

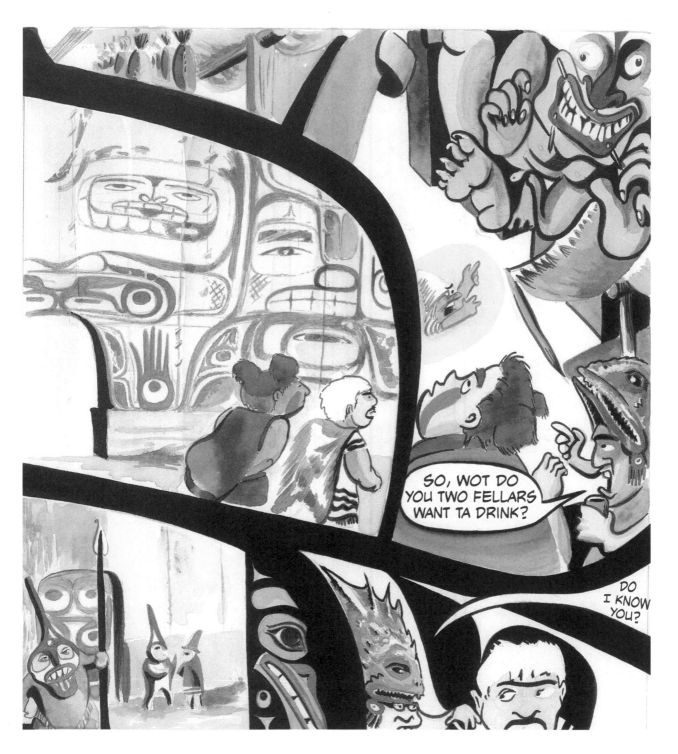

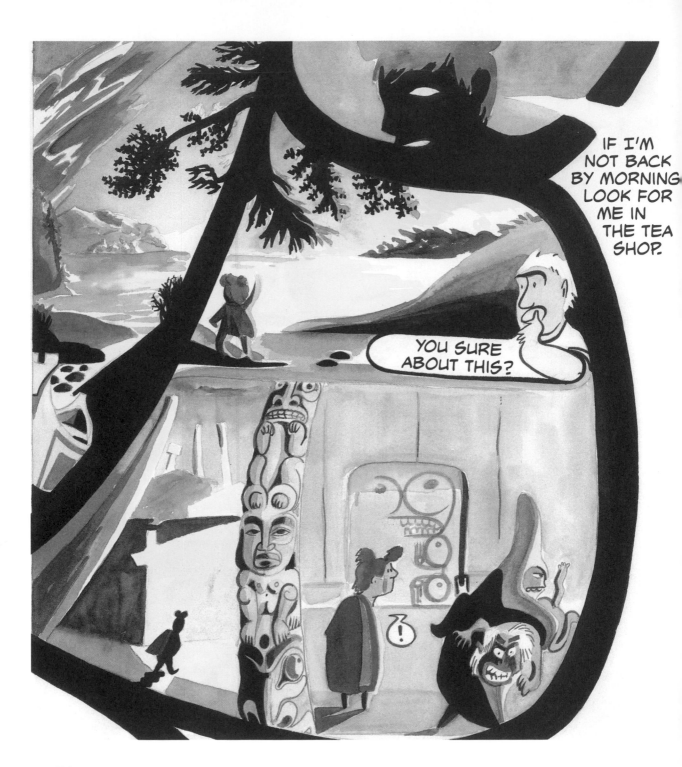

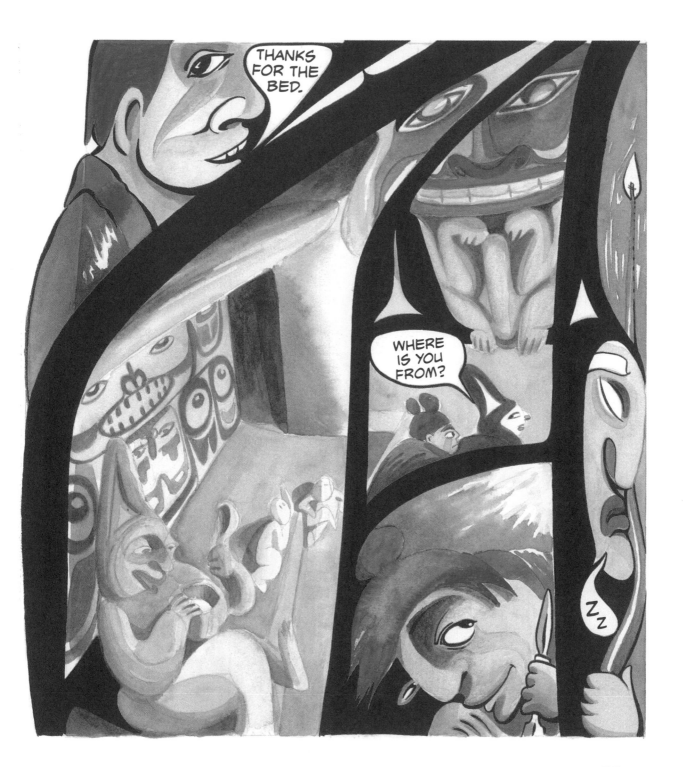

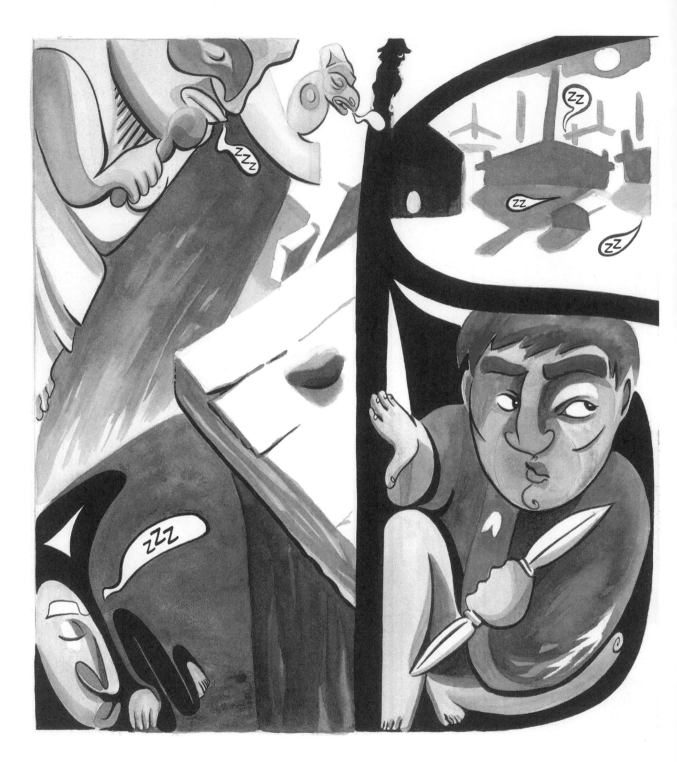

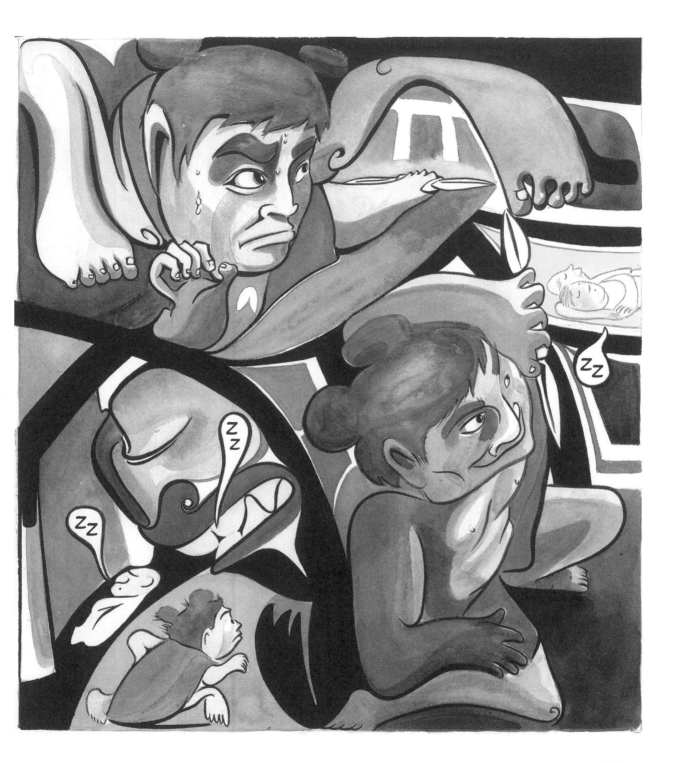

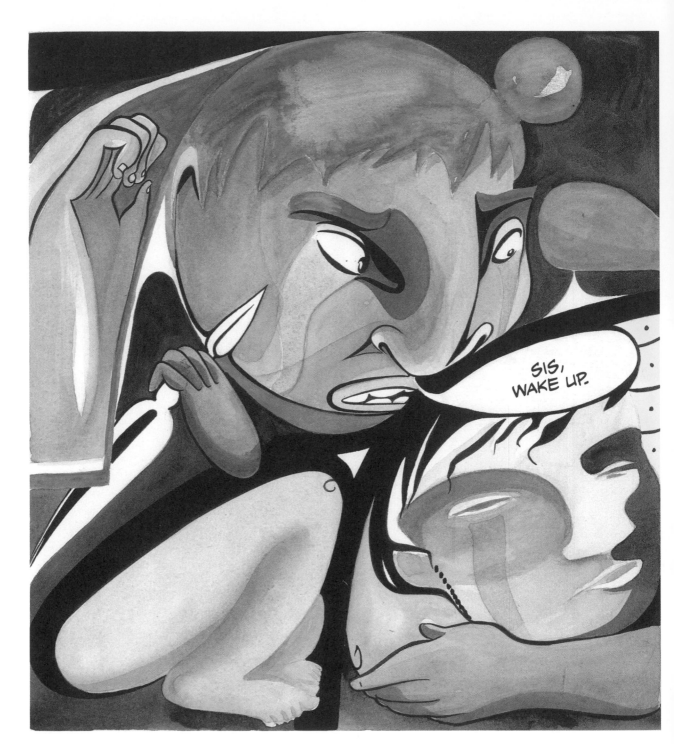

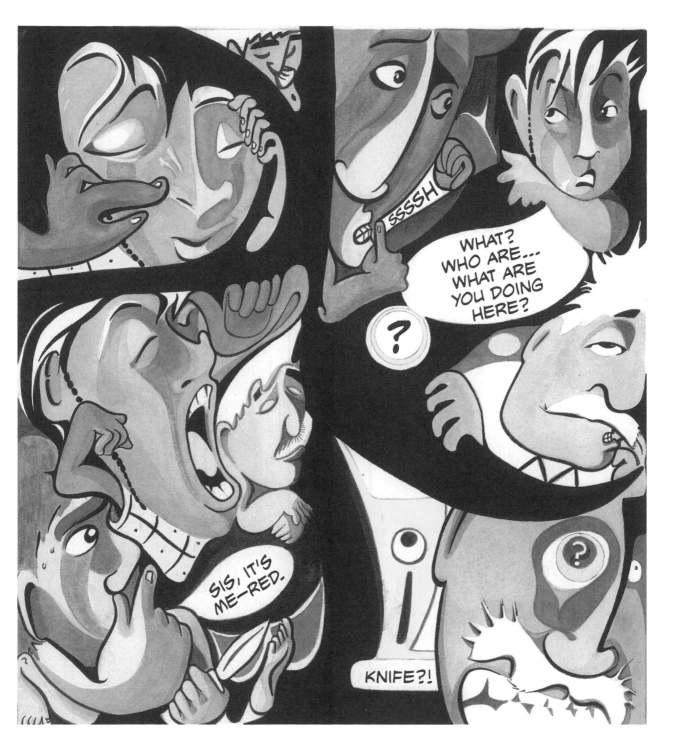

59

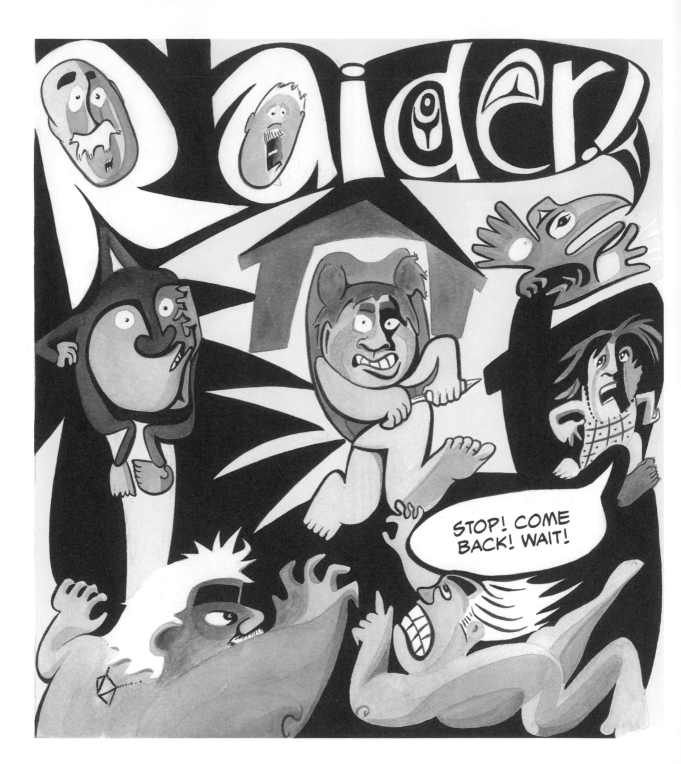

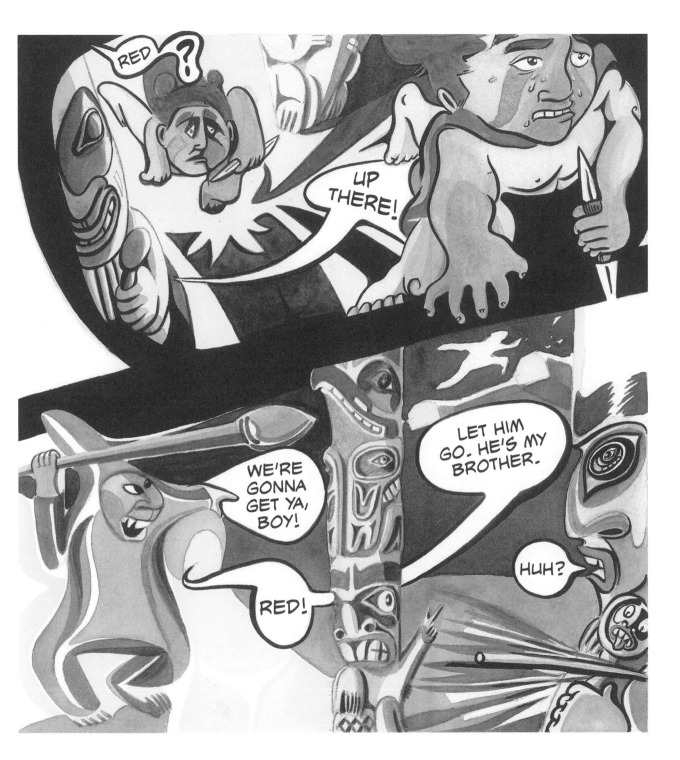

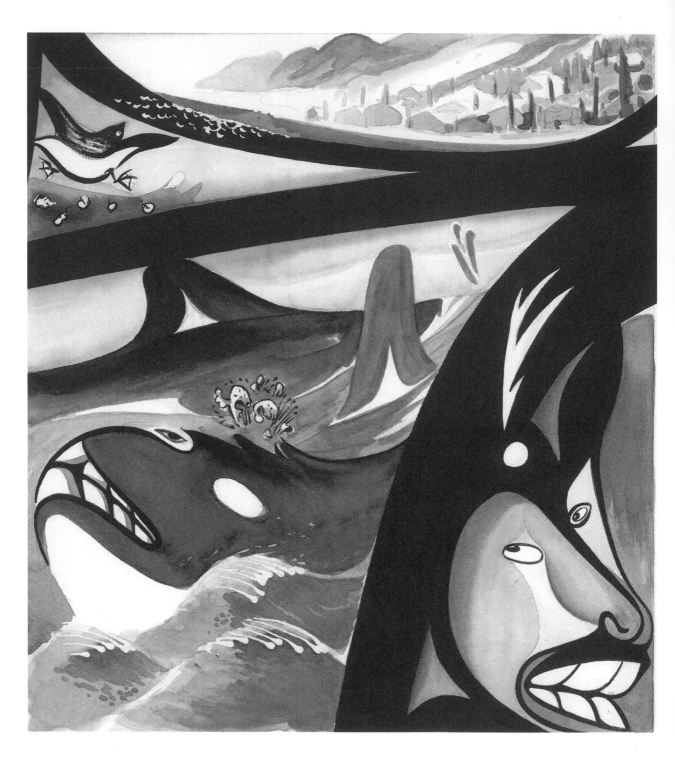

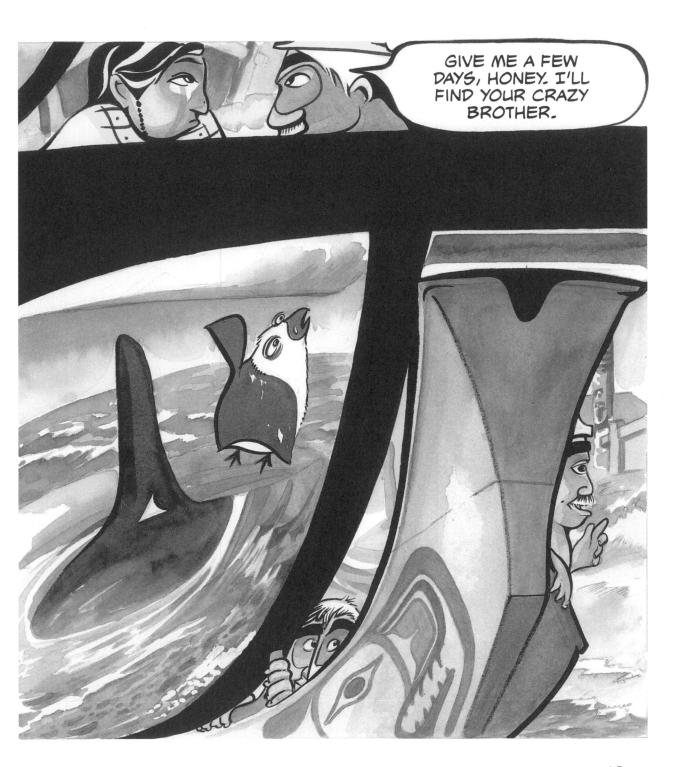

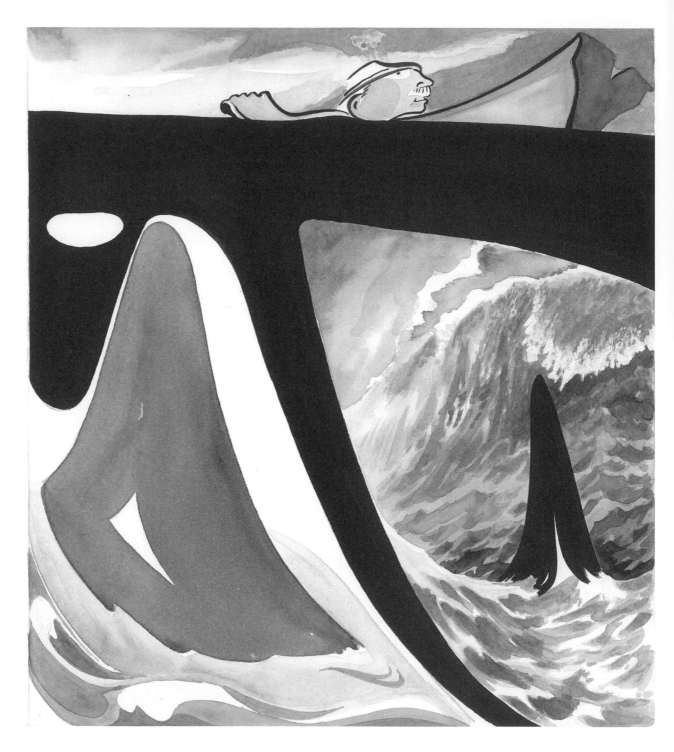

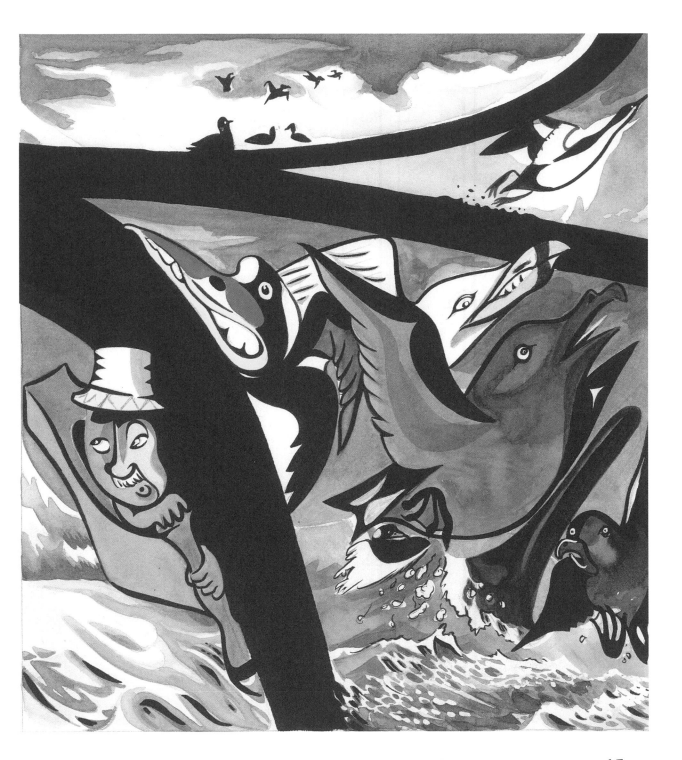

65

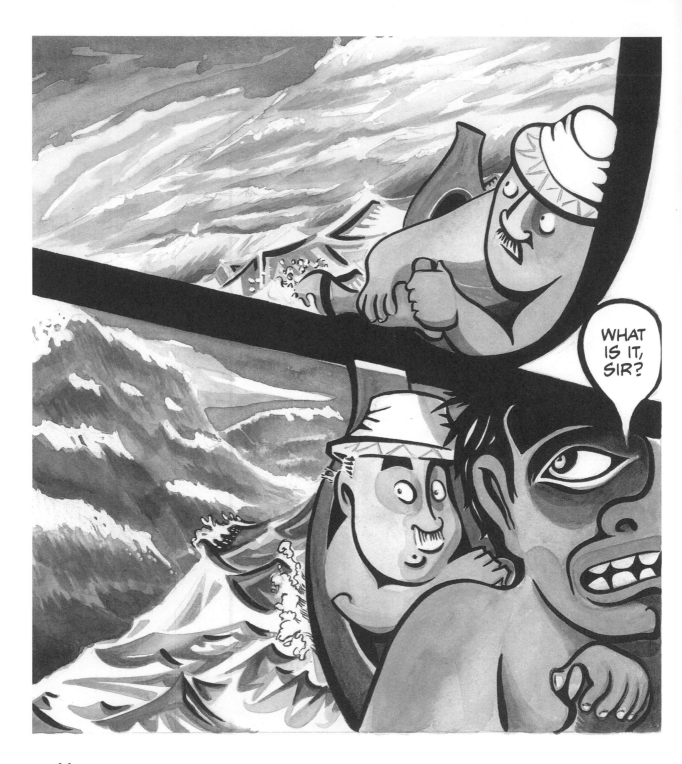

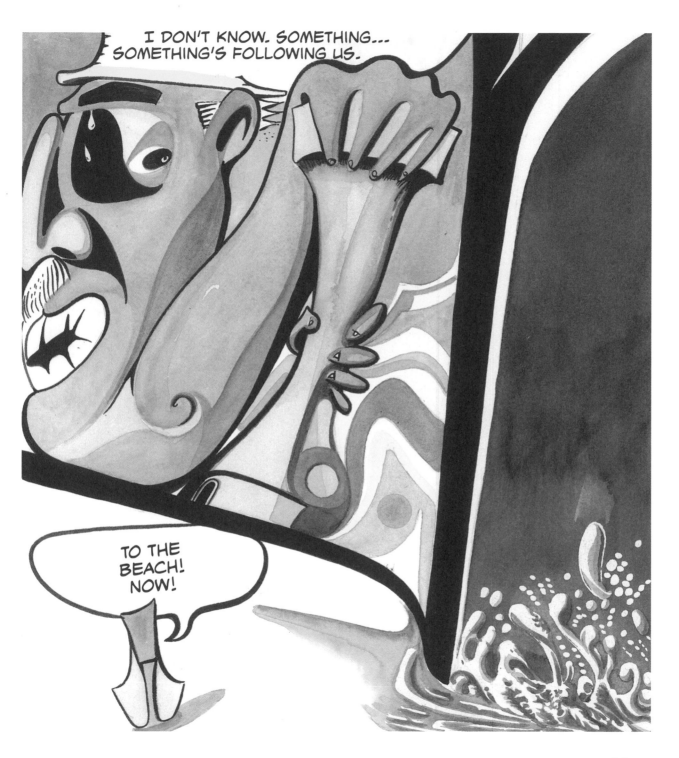

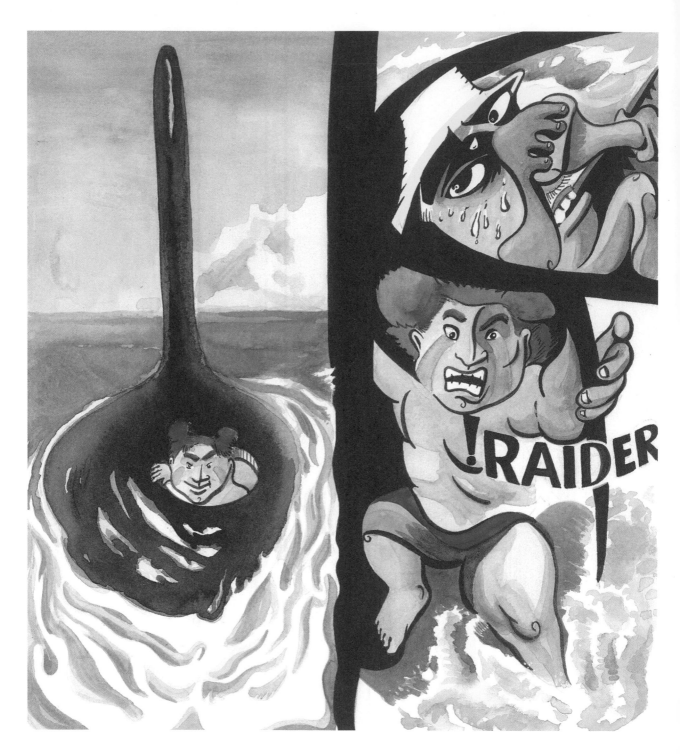

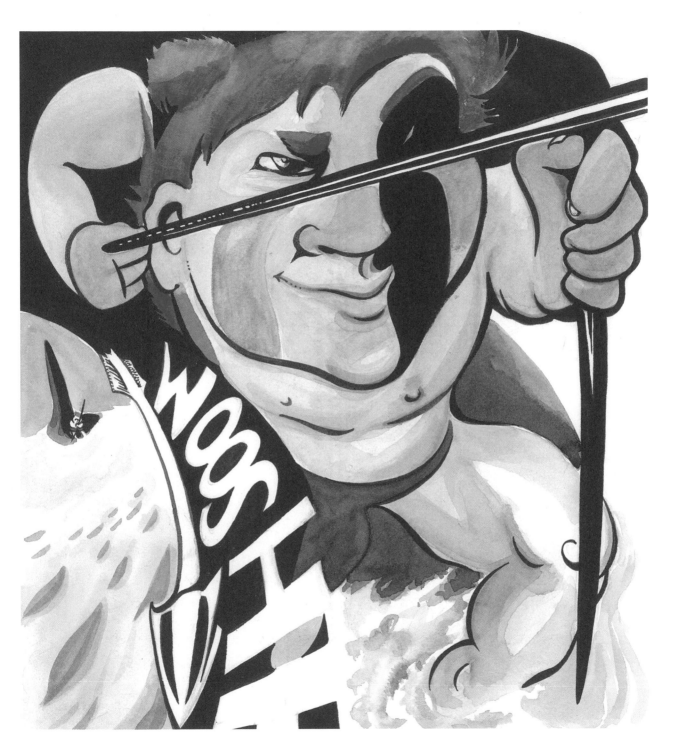

69

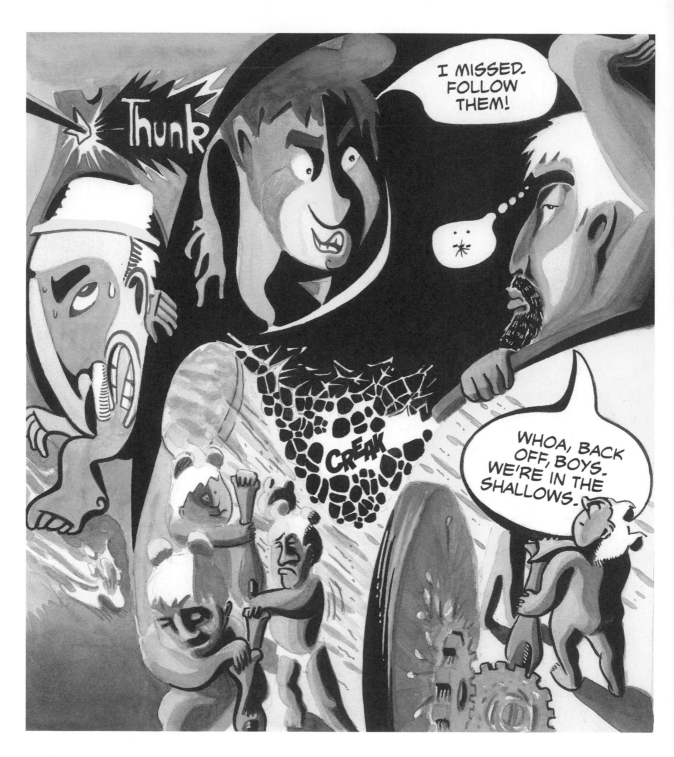

70

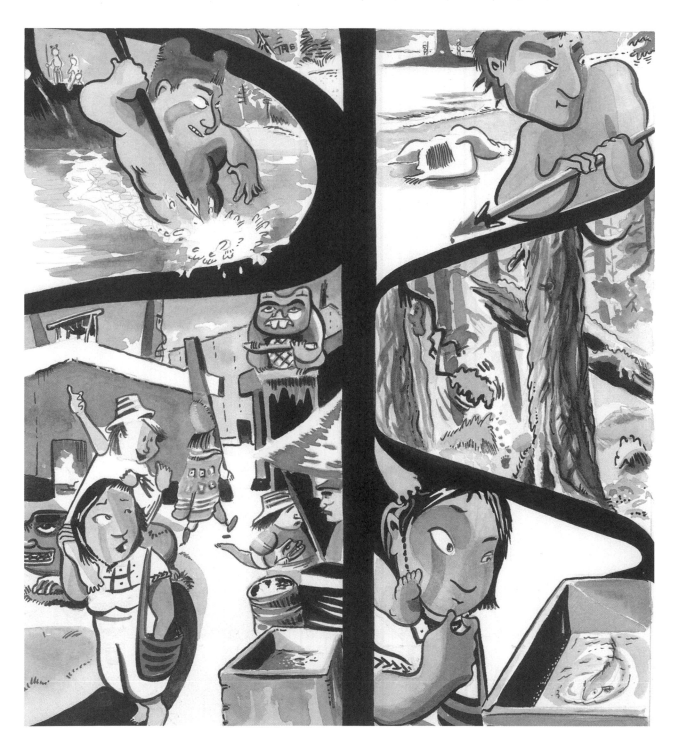

71

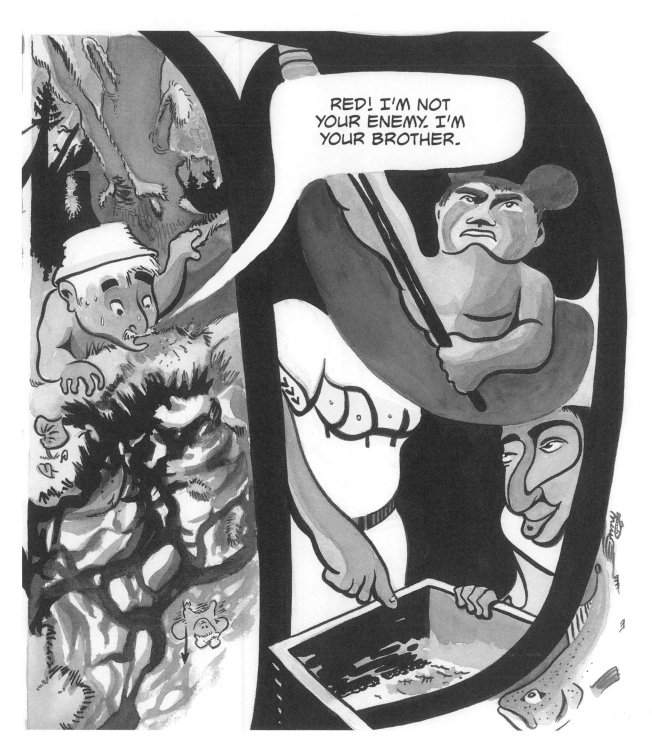

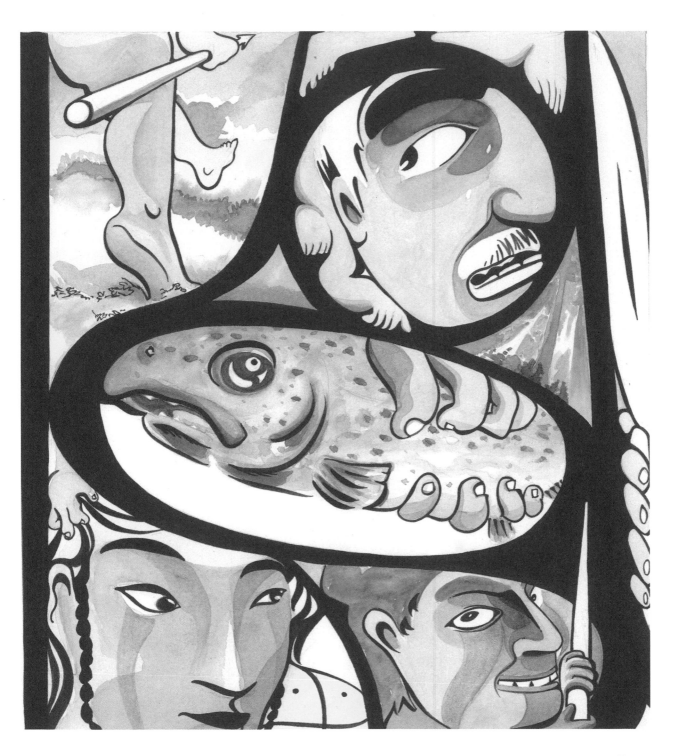

73

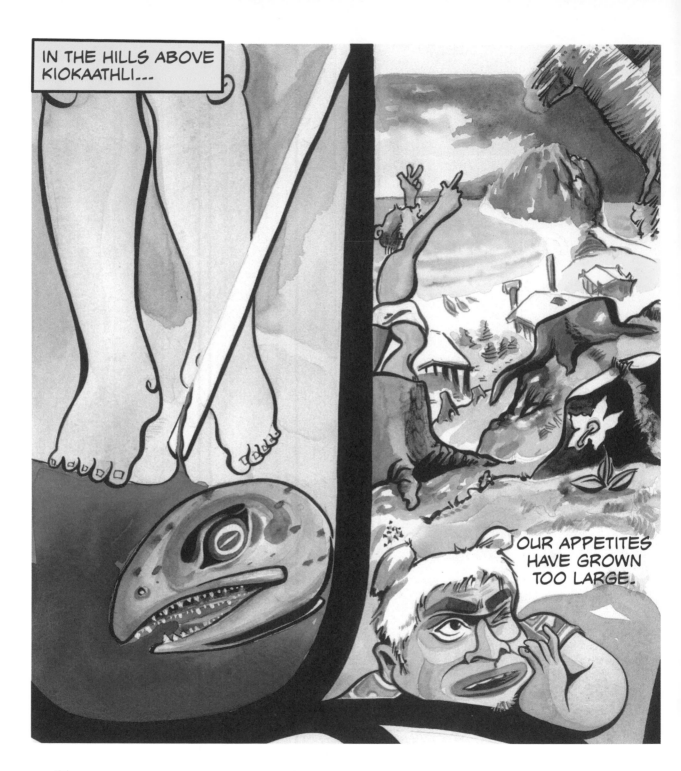

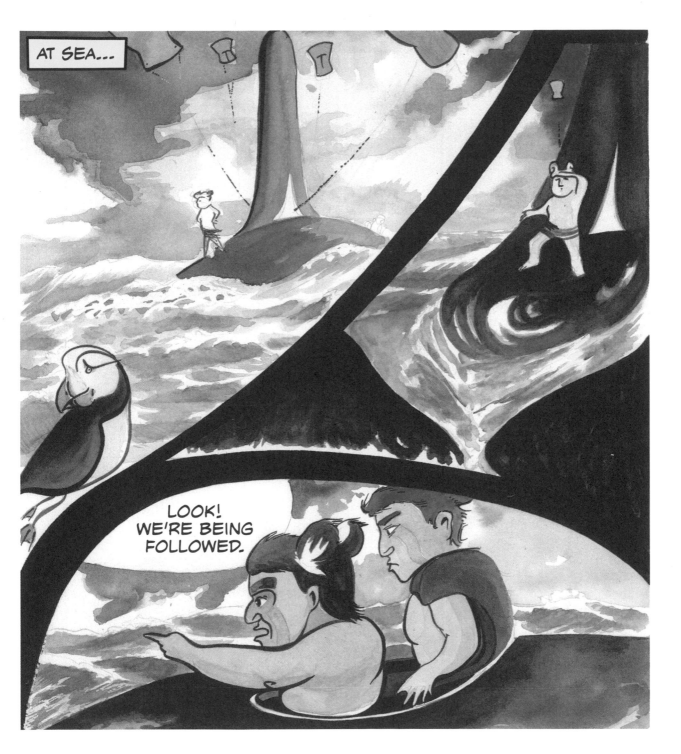

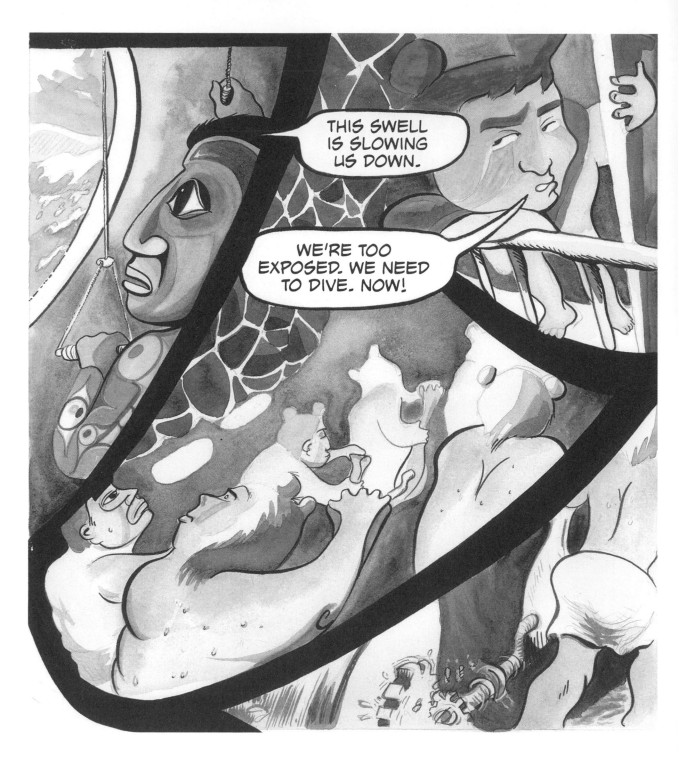

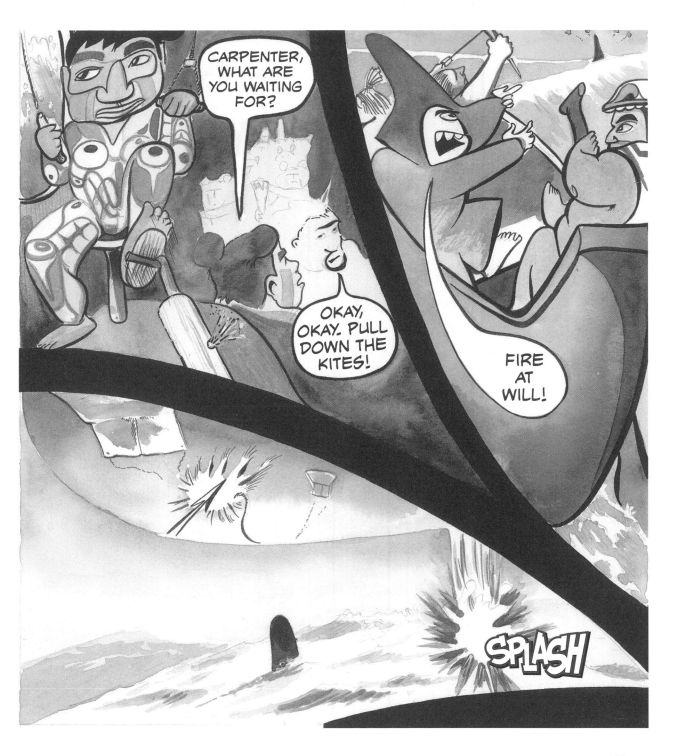

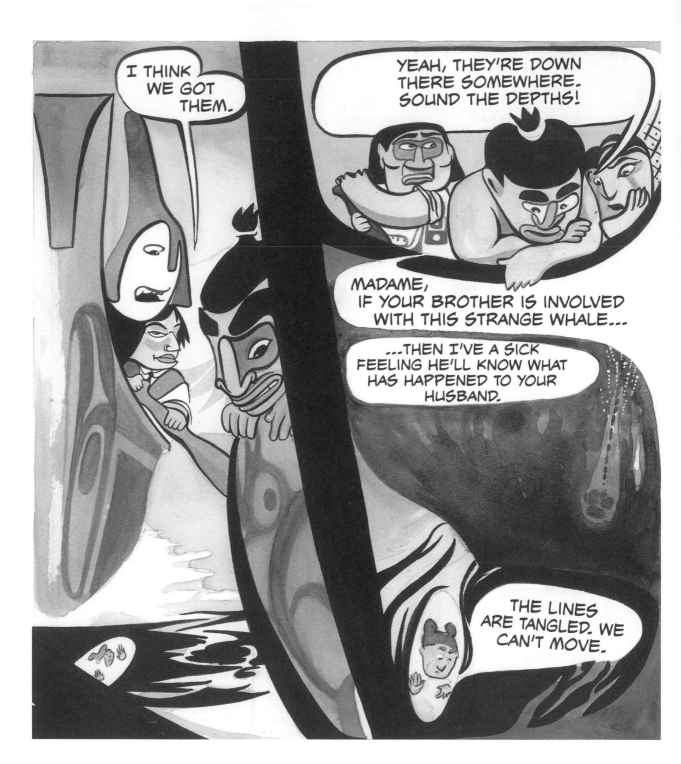

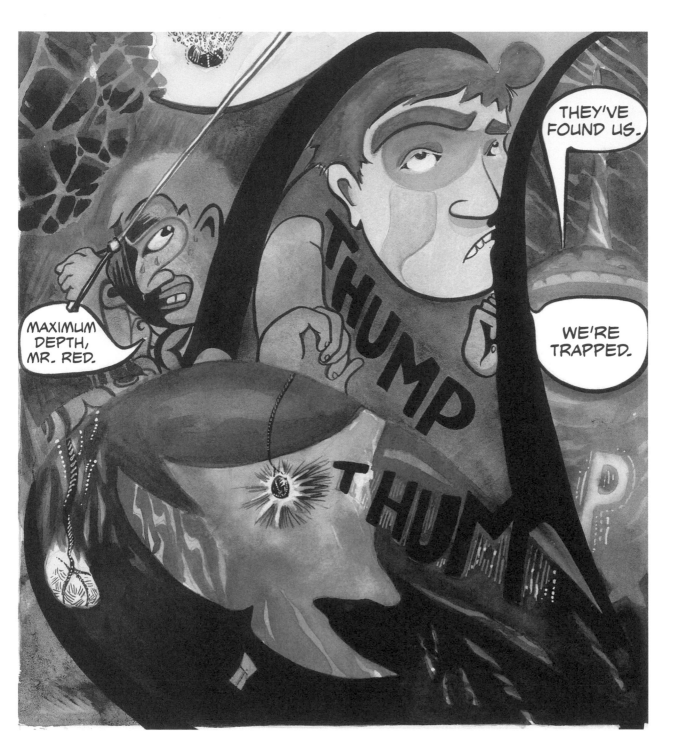

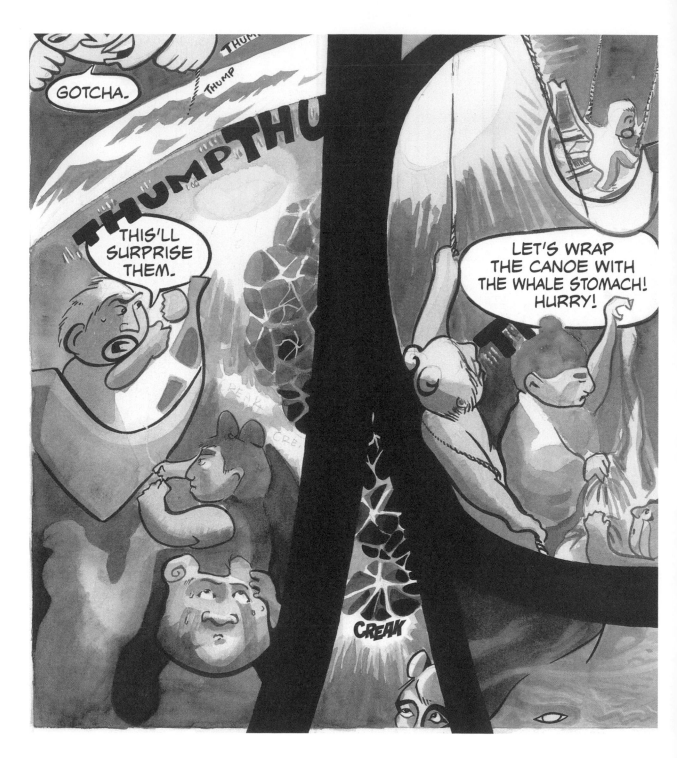

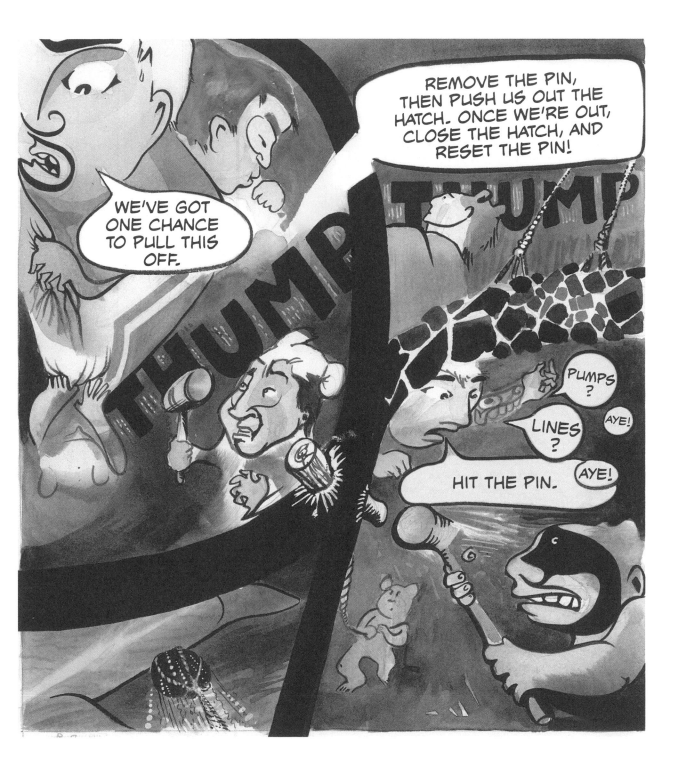

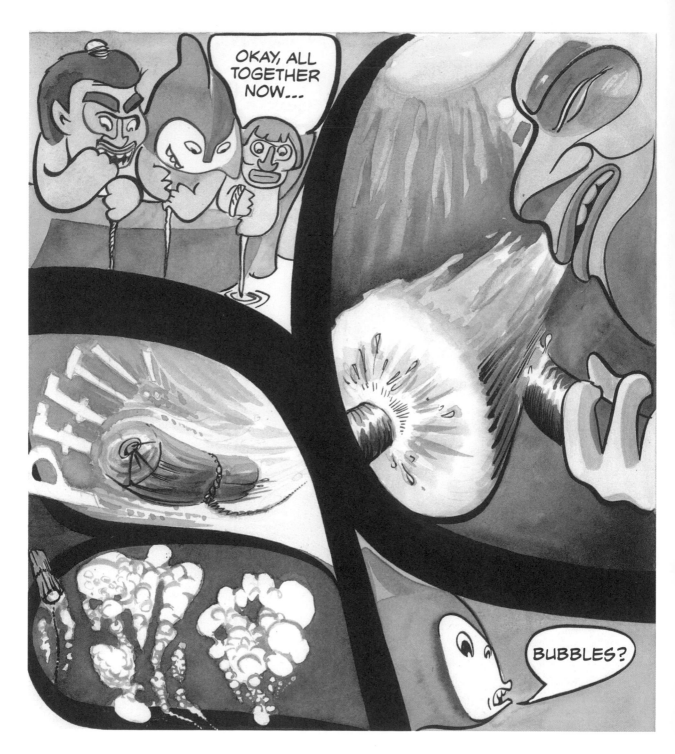

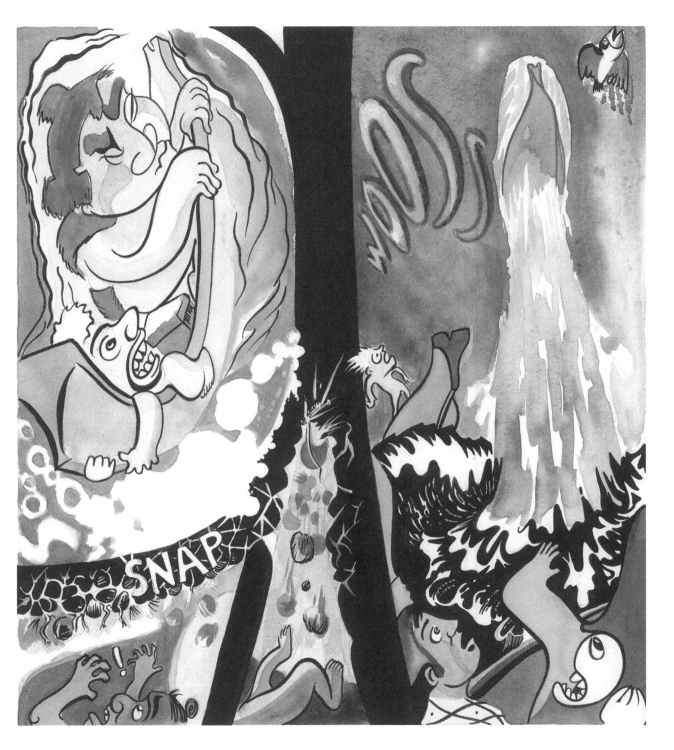

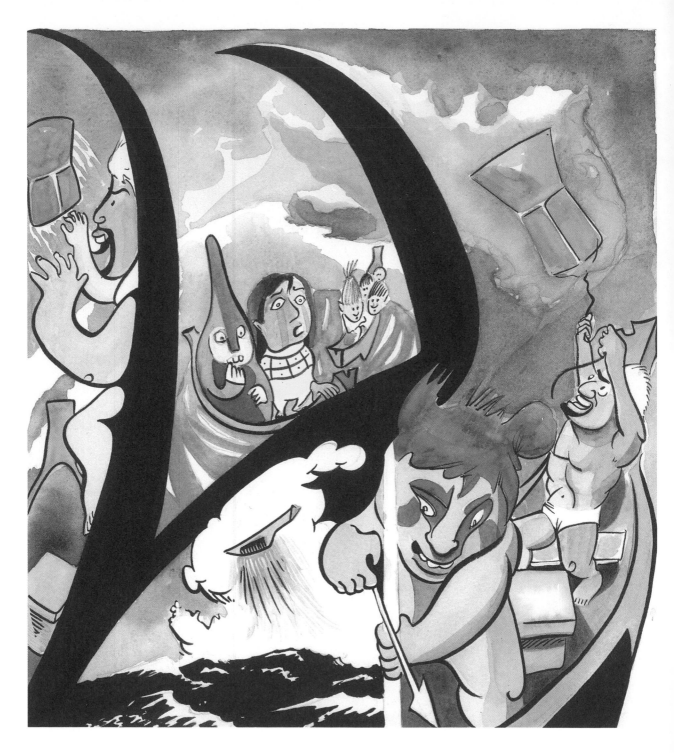

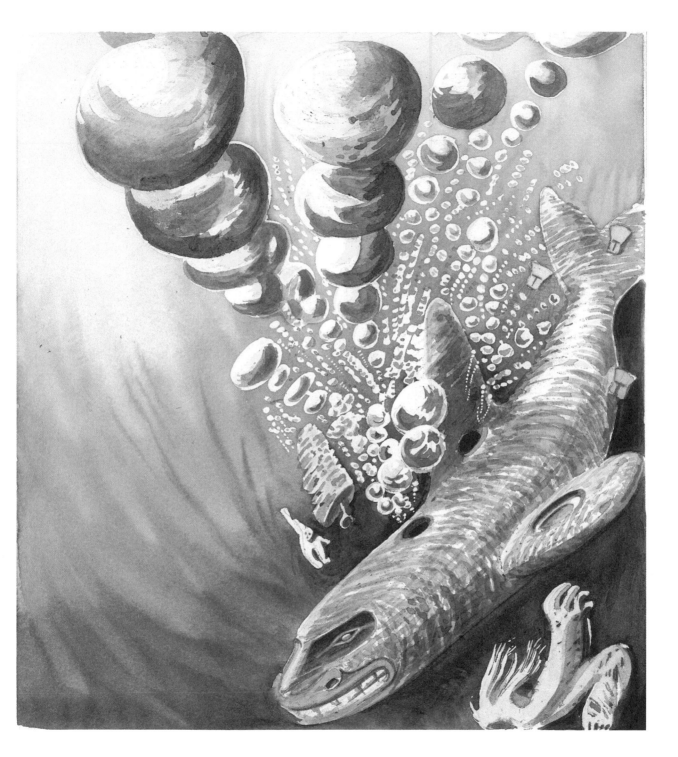

85

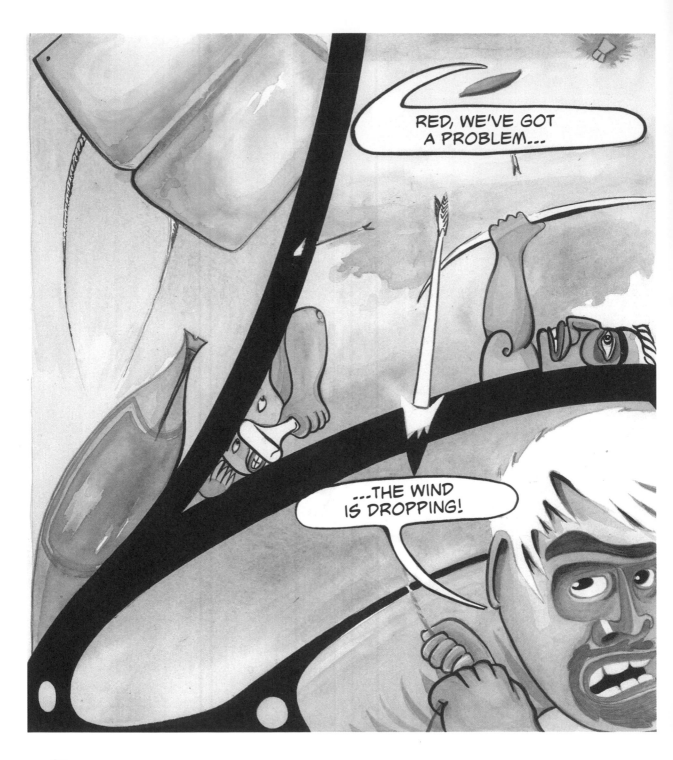

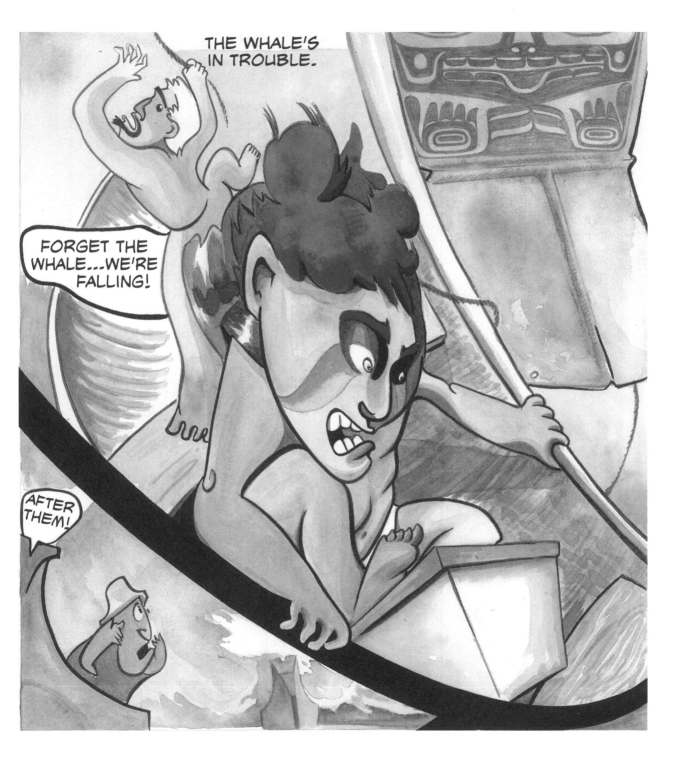

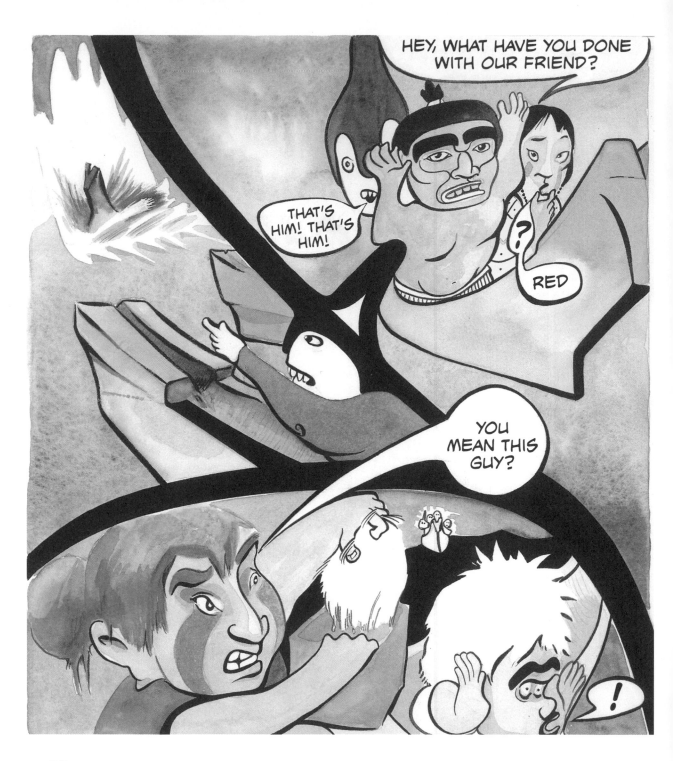

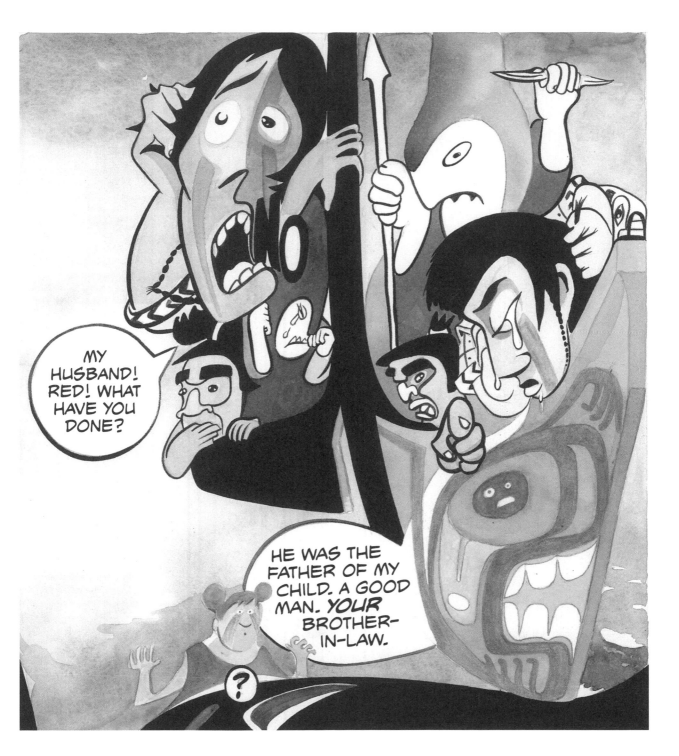

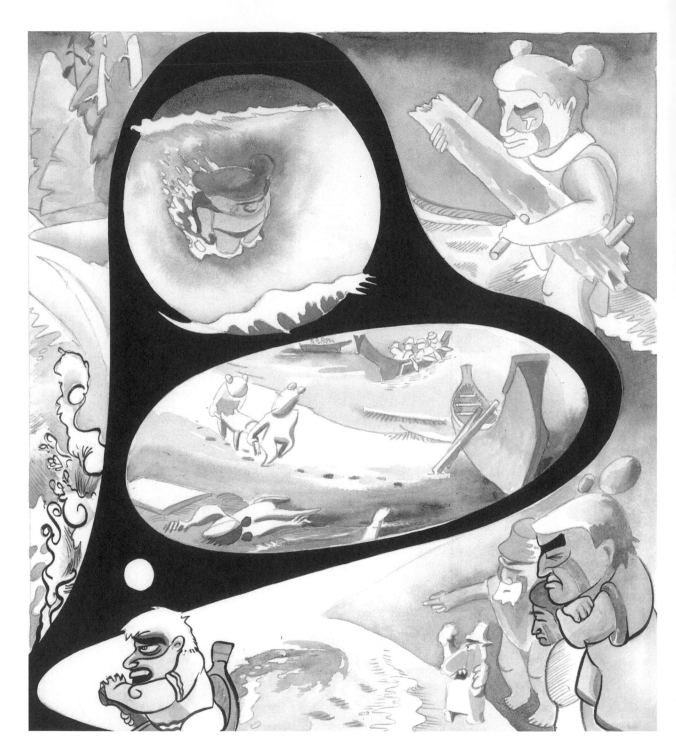

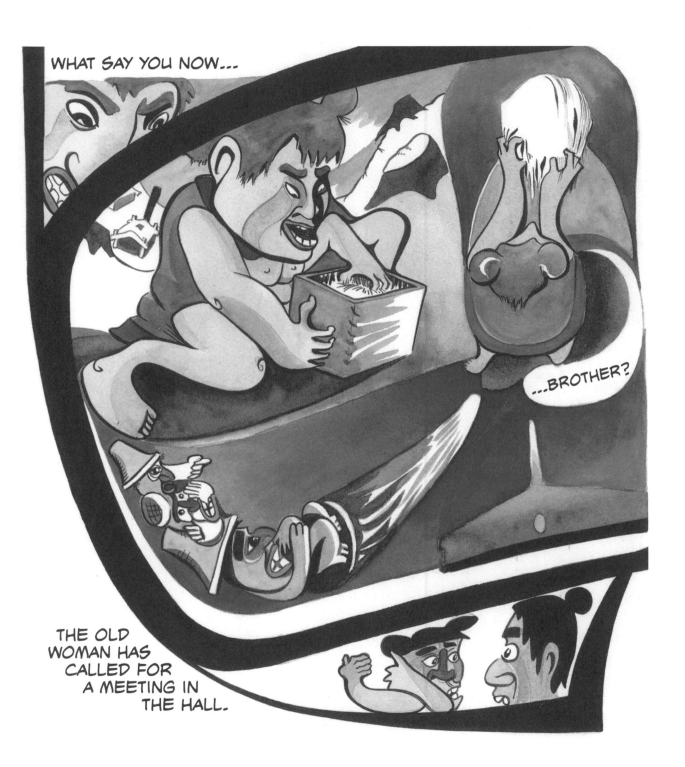

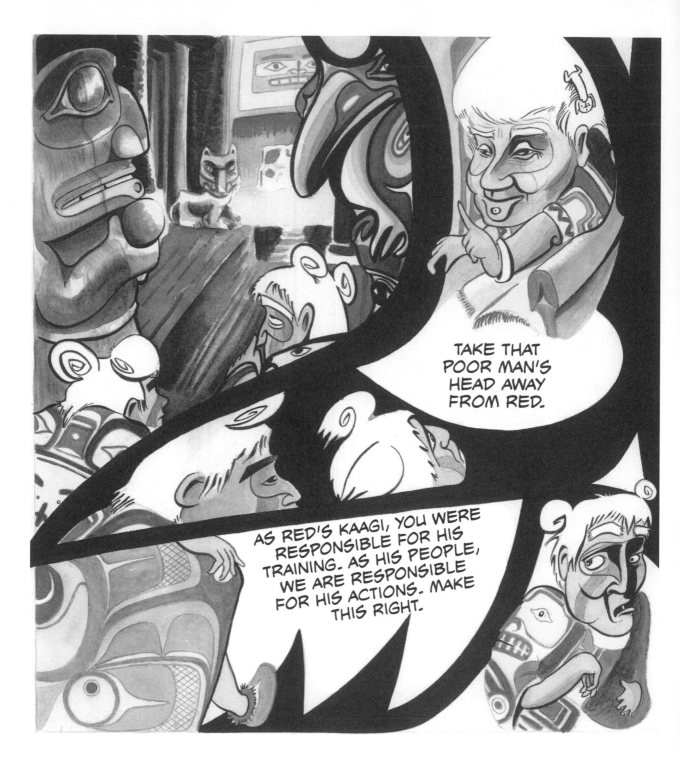

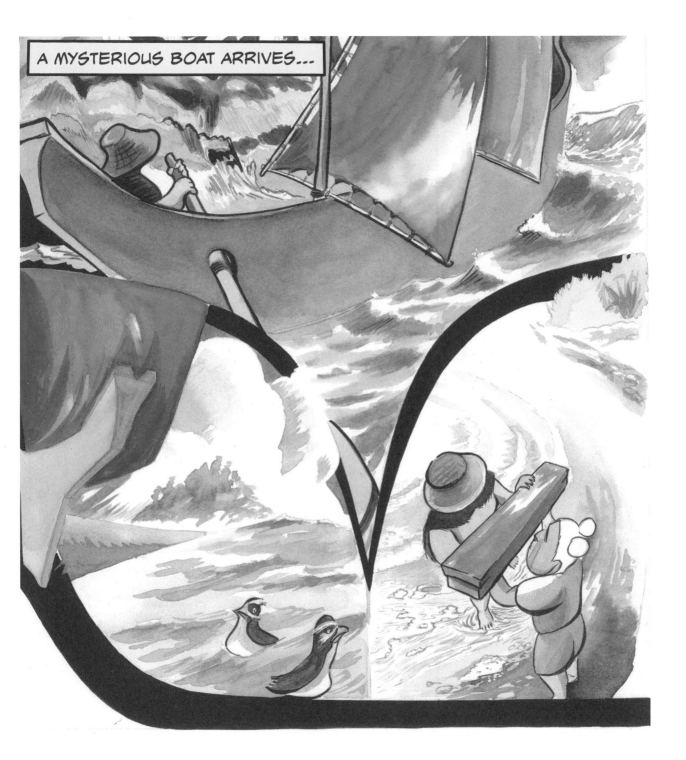

A MYSTERIOUS BOAT ARRIVES...

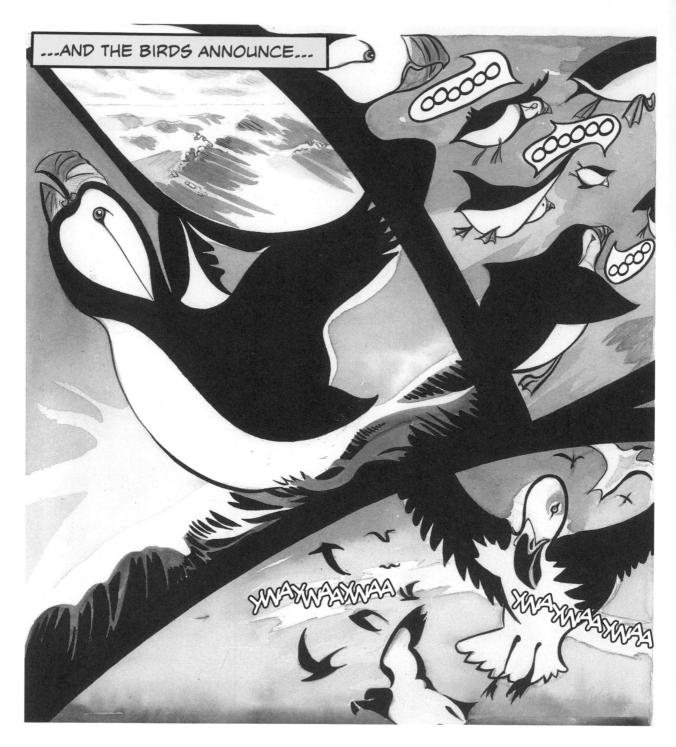

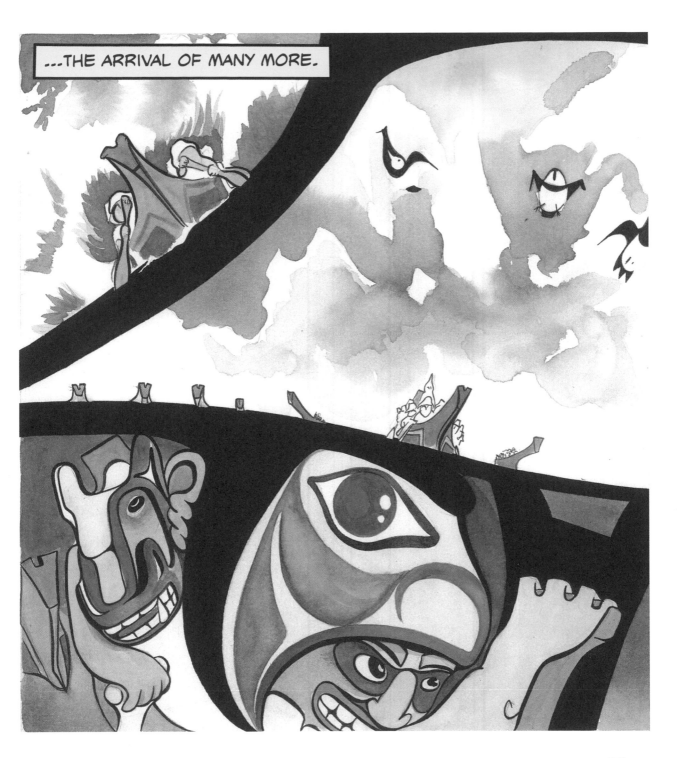

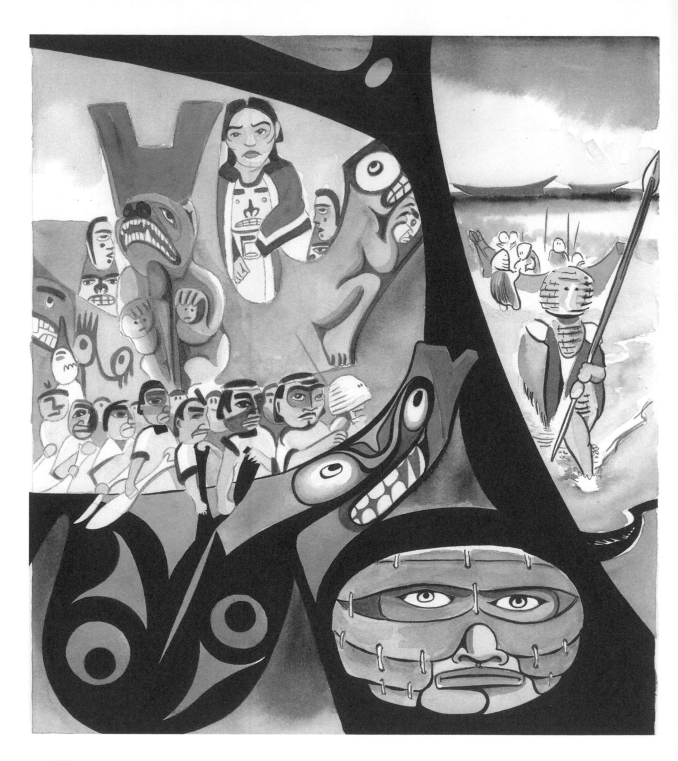

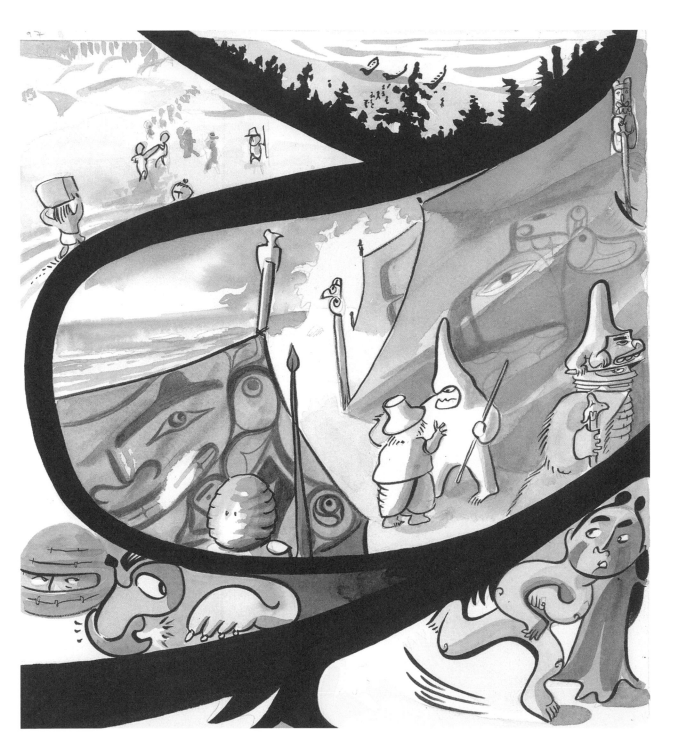

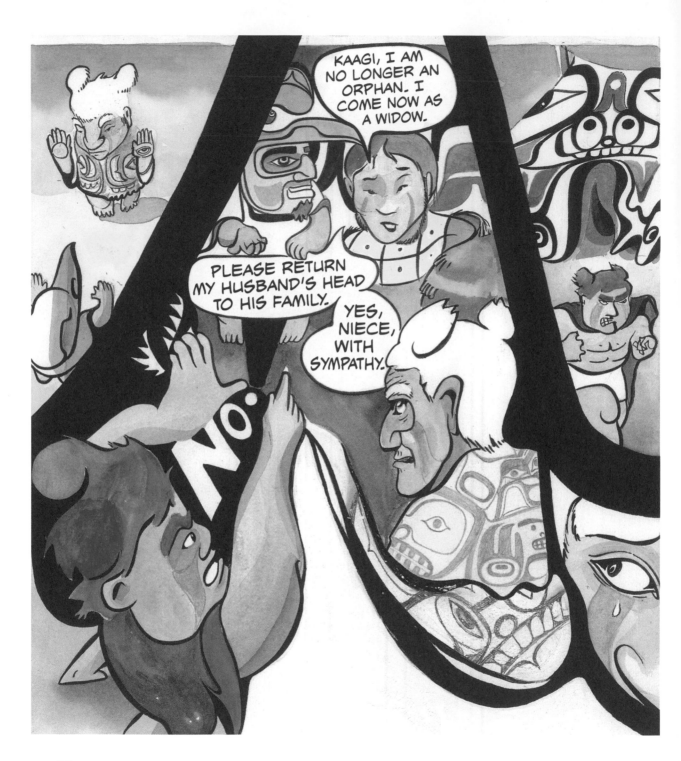

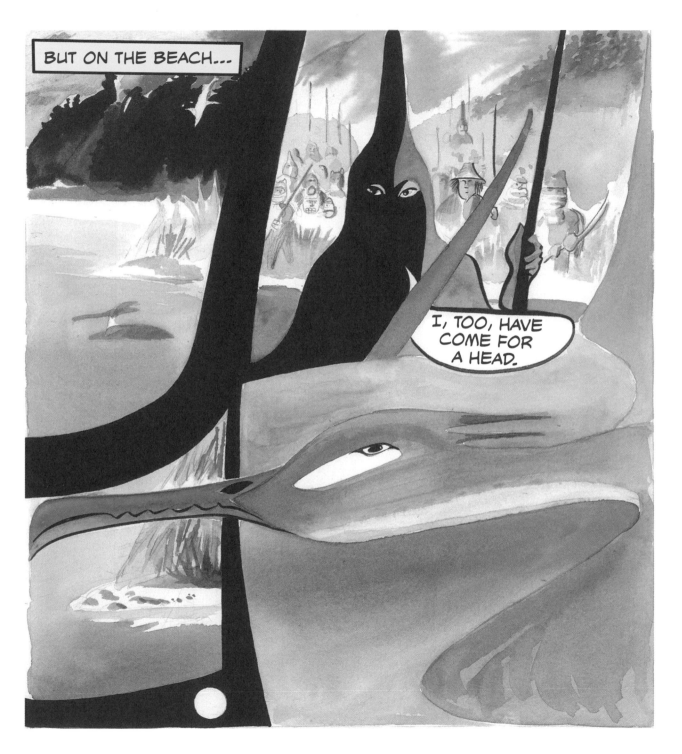

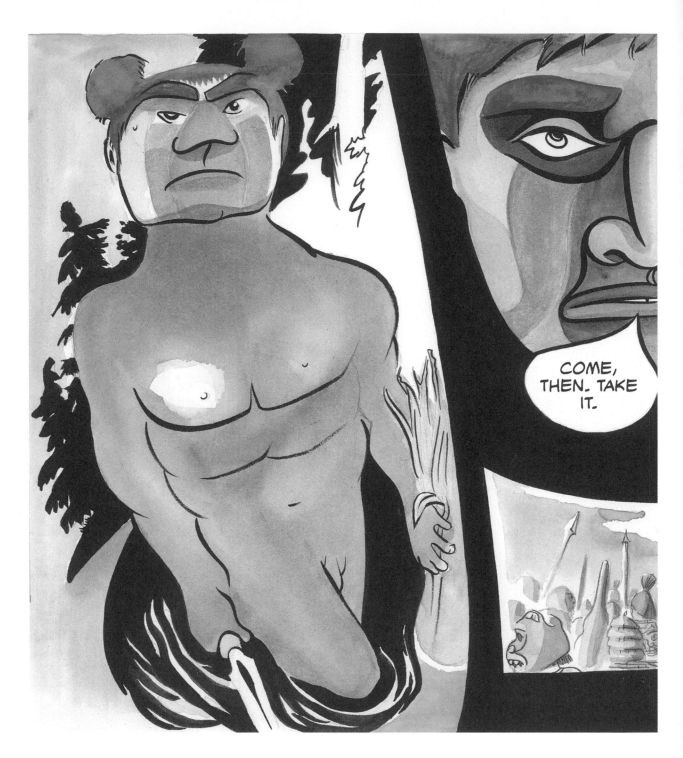

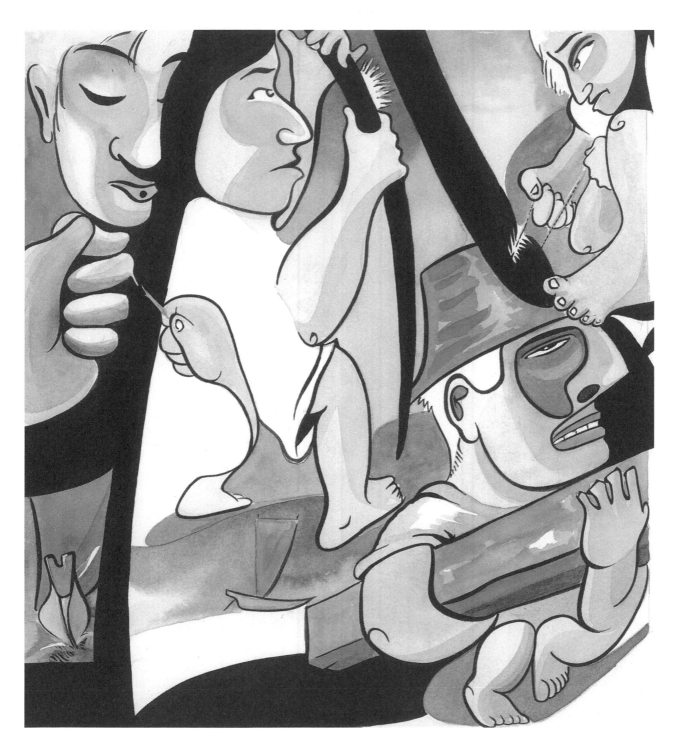

101

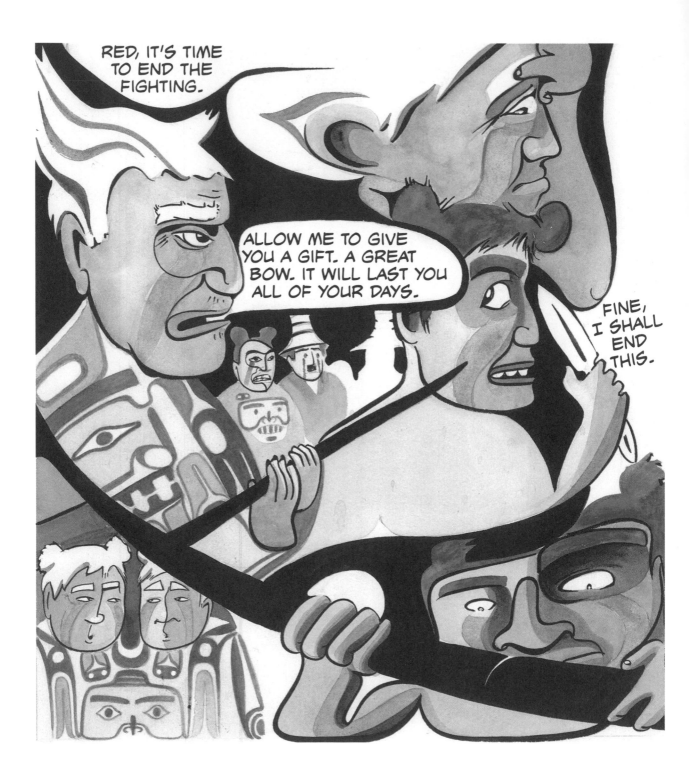

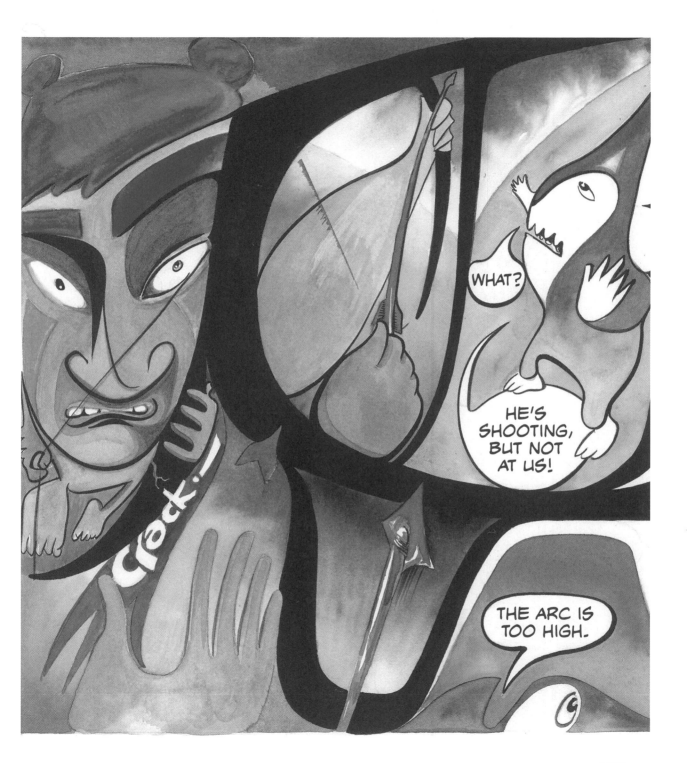

103

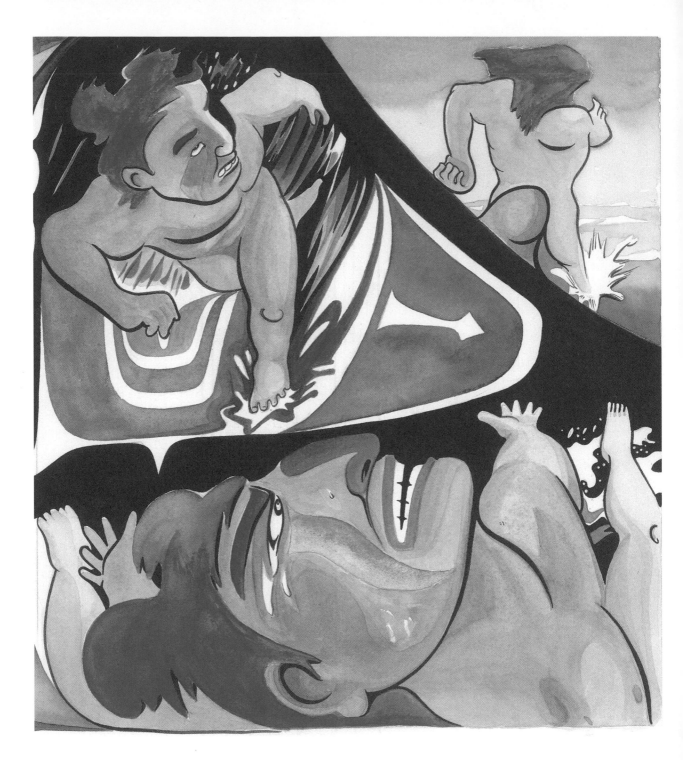

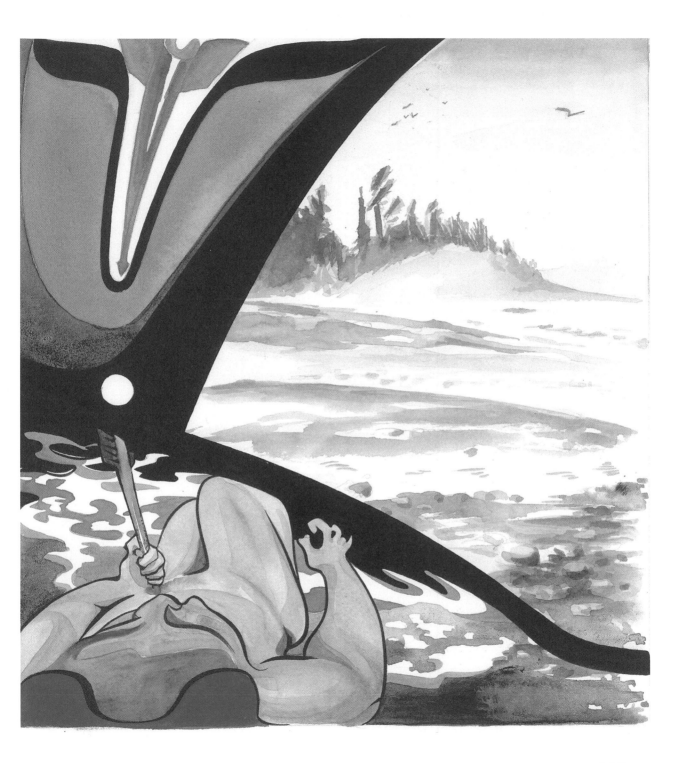

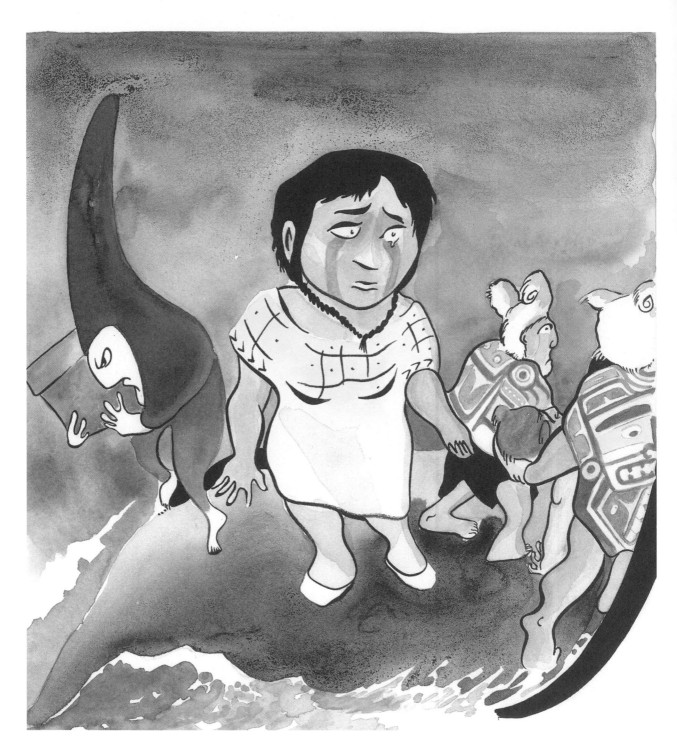

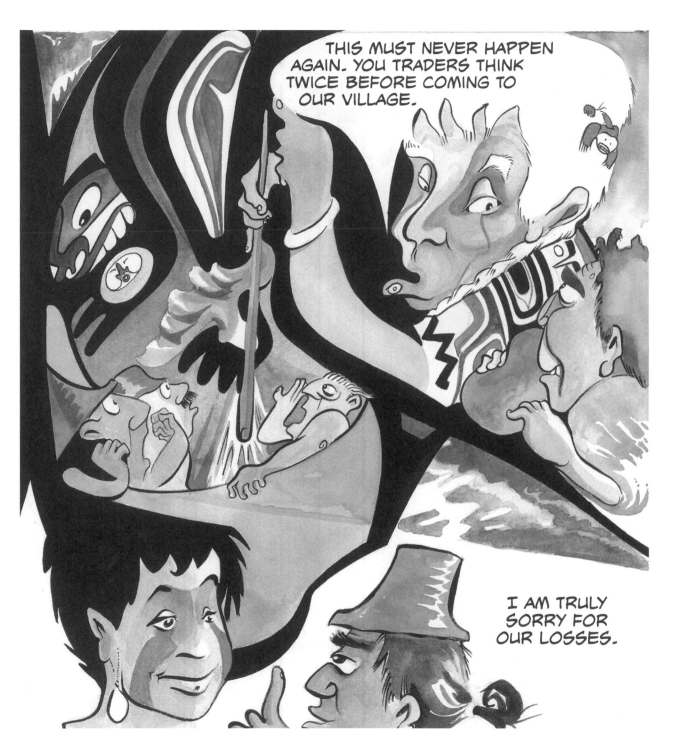

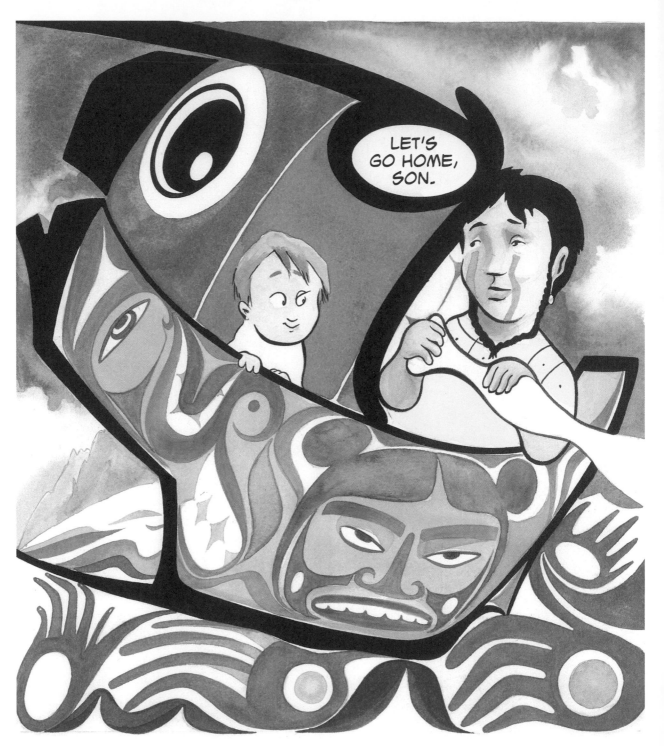

ACKNOWLEDGEMENTS

TO BRUCE, EVER RESPECTFUL AND GENEROUS, WHO MADE THE SPACE BETWEEN HAIDA AND CANADA A PLACE OF CLARITY AND HONESTY;

TO TOM, WHO, IN THOSE LAST FEW MOMENTS WE EVER SPENT TOGETHER, TAUGHT ME HOW TO DIE;

TO NAOMI, WHO SHOWED ME HOW TO EMBRACE AGE, AND BABS, WHO IS STILL TRYING TO TEACH ME GRACE;

TO LAUNETTE AND TSUAAY, WHO EMBRACE ME:

I, THE POOR STUDENT, AM MUCH NOURISHED BY YOU ALL.

MNY

OVERLEAF

RED IS MORE THAN A COLLECTION OF BOUND PAGES, SOMETHING MORE THAN A STORY TO BE READ PAGE BY PAGE. *RED* IS ALSO A COMPLEX OF IMAGES, A COMPOSITE—ONE THAT WILL DEFY YOUR ABILITY TO EXPERIENCE STORY AS A SIMPLE PROGRESSION OF EVENTS. TURN THE PAGE TO SEE THE ENTIRE WORK.

I WELCOME YOU TO DESTROY THIS BOOK. I WELCOME YOU TO RIP THE PAGES OUT OF THEIR BINDINGS. FOLLOWING THE LAYOUT PROVIDED OVERLEAF AND USING THE PAGES FROM TWO COPIES OF THIS BOOK, YOU CAN RECONSTRUCT THIS WORK OF ART (NOTE: THIS FORMLINE ILLUSTRATION IS ALSO REPRODUCED ON THE FLIP SIDE OF THE DUST JACKET.)

MNY

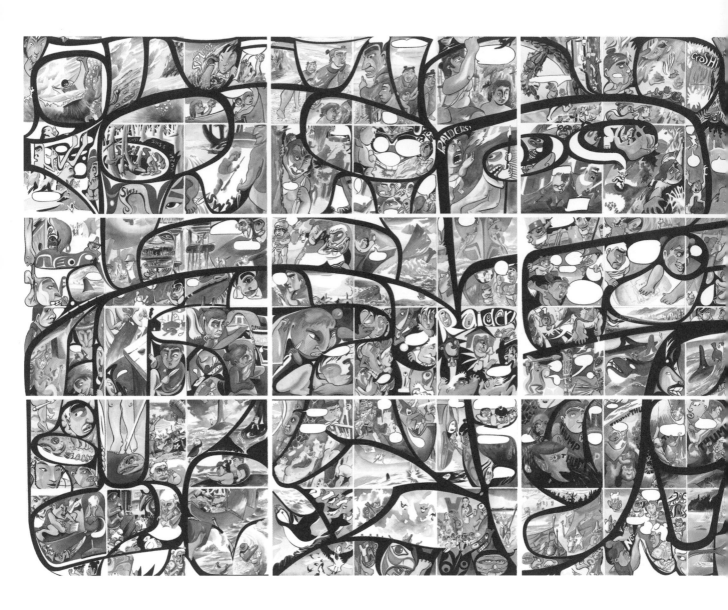

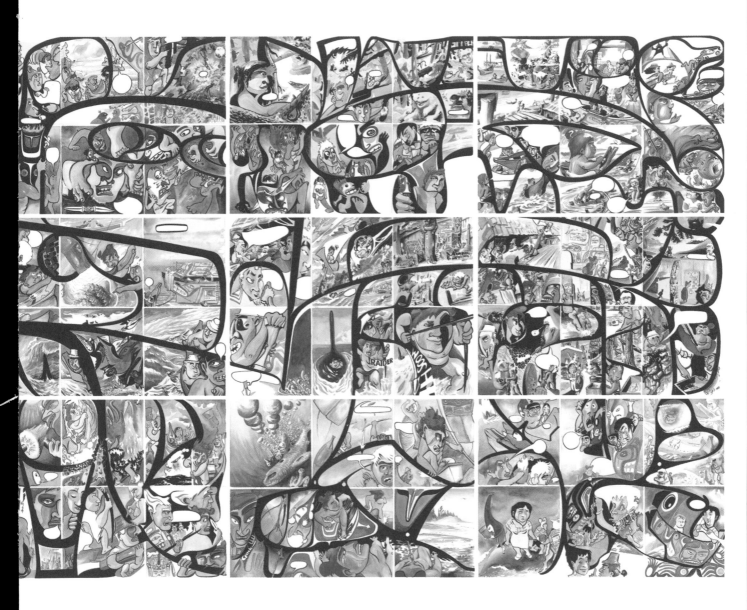

MICHAEL NICOLL YAHGULANAAS (MNY) IS
THE FATHER OF A NEW VISUAL GENRE CALLED
HAIDA MANGA, WHICH REFRAMES CLASSIC
HAIDA IMAGERY AND NARRATIVES INTO A POPU-
LIST GRAPHIC LITERATURE. A HAIDA BY BIRTH,
MNY WAS FORMALLY INTRODUCED TO THE
DISCIPLINE OF TRADITIONAL ICONOGRAPHY
BY HIS ELDER COUSIN, ACCLAIMED PAINTER,
CARVER AND PRINTMAKER ROBERT DAVIDSON.
HE ALSO STUDIED WITH CANTONESE ARTIST
CAI BEN KWON.

 HAIDA MANGA IS A GENRE THAT REFLECTS
BOTH MNY'S INDIGENOUS AND COLONIAL HERI-
TAGES AND IS INFLUENCED BY HIS LONG AND
ACTIVE CAREER IN SOCIAL AND ENVIRONMEN-
TAL JUSTICE ISSUES ON HIS HOME ISLANDS

OF HAIDA GWAII AND THROUGHOUT THE PACIFIC
RIM. HE SPENT MUCH OF THE 1980S AND 1990S
IN PUBLIC SERVICE FOR THE HAIDA NATION, A
CAREER MARKED BY A SERIES OF SUCCESSES
AGAINST MINING, LOGGING AND POLITICAL
INTERESTS.

 IN 2001 MNY BEGAN TO EXPLORE THE
BOUNDARIES THAT DESCRIBE "TRADITIONAL"
HAIDA ART. HE BEGAN CREATING POP-GRAPHIC
NARRATIVES AND RIFFING ON TRADITIONAL ORAL
STORIES AND PAINTING TECHNIQUES, AND HE
QUICKLY DEVELOPED THE DISTINCTIVE HAIDA
MANGA ART FORM FOR WHICH HE IS INTERNA-
TIONALLY KNOWN. HE HAS EXHIBITED IN ASIA,
EUROPE AND NORTH AMERICA. HIS BOOKS
INCLUDE *FLIGHT OF THE HUMMINGBIRD, A TALE
OF TWO SHAMANS, THE LAST VOYAGE OF THE
BLACK SHIP,* AND *HACHIDORI,* A BESTSELLER IN
JAPAN. HE LIVES IN CANADA WITH HIS WIFE AND
DAUGHTER, CLOSE TO THE TWO SISTERS MOUN-
TAINS ABOVE AN ISLAND IN THE SALISH SEA.

WWW.MNY.CA